CLEVEDON
THROUGH TIME
Will Musgrave

AMBERLEY PUBLISHING

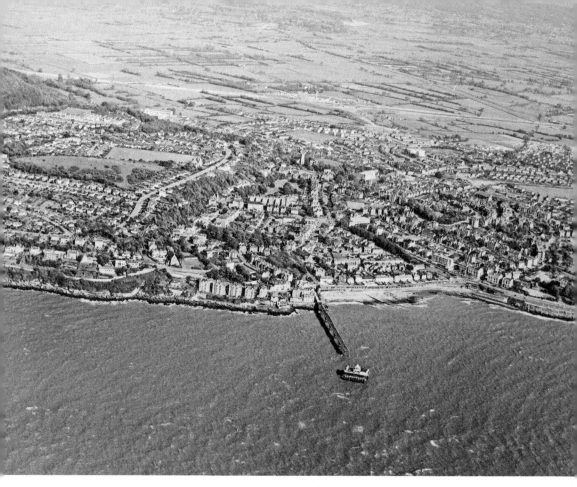

Aerial photograph of Clevedon in the 1970s.

First published 2014

Amberley Publishing
The Hill, Stroud, Gloucestershire, GL5 4EP
www.amberley-books.com

Copyright © Will Musgrave, 2014

The right of Will Musgrave to be identified as the Author
of this work has been asserted in accordance with the
Copyrights, Designs and Patents Act 1988.

ISBN 978 1 4456 2064 0 (print)
ISBN 978 1 4456 2071 8 (ebook)

British Library Cataloguing in Publication Data.
A catalogue record for this book is available from the
British Library.

Typesetting by Amberley Publishing.
Printed in Great Britain.

Introduction

Nestled on the shoreline of the Severn Estuary, the North Somerset town of Clevedon, with its distinctive pier, is one of the most picturesque seaside resorts in England. It has grown from an insignificant cluster of rural dwellings at the end of the eighteenth century to a bustling urban community in the space of two short centuries. Despite its rapid growth, it has managed to retain its charm and appeal – today people happily promenade along the seafront on a sunny bank holiday much as their great-grandparents did in Edwardian days.

Clevedon has been shaped by its geography. The collection of low hills (sometimes rather imaginatively likened to the seven hills of Rome) on which the town is built on and around, along with the marshland fields to the south, have dictated the layout and character of the town. To the west is the imposing presence of the Severn Estuary, with its miles of mudflats, rocky foreshore and treacherous waters (at over 14 metres it has the second highest tidal range in the world). Clevedon owes its existence to the Estuary, as it was the popularity of seaside resorts in Georgian England (aided by the craze for sea bathing initiated by the Prince Regent, later George IV) that saw the sleepy backwater, along with its neighbours Weston-super-Mare and Portishead, emerge as a popular holiday location. People flocked to the resort to enjoy the bracing sea air and the seaside entertainment, which by the mid-Victorian era would include a walk along the pier jutting out from the northern headland of the beach front.

Not much is known of Clevedon prior to its emergence in the nineteenth century. The name Clevedon derives from the Old English words *cleve*, meaning cleave or cleft, and *don*, meaning hill. It is mentioned in the Domesday Book of 1086 as a holding with eight villagers and ten small holders in the Portbury Hundred belonging to Matthew of Mortaigne. For much of the next 700 years, Clevedon remained a rural settlement comprised mainly of farm labourers, and at the turn of the nineteenth century, Clevedon still had a population of just 334 inhabitants. There were, however, three distinctive buildings that set it apart from its neighbouring villages: the medieval Highdale Farm, St Andrew's church (the 'Old Church') on the western tip of the community and Clevedon Court. The Court lies to the east on the Bristol road, just before the M5 motorway, which scythes through the Gordano valley. Dating from the early fourteenth century, the house had a number of owners before it was purchased in 1709 by Abraham Elton, a rich Bristol merchant. The history of Clevedon is inextricably entwined with the beneficent Elton family, who shaped the town through philanthropic donations and astute social programmes. The Revd Sir Abraham Elton (1750–1842) and his wife Mary began a system of footpaths and walkways through the town, raised funds for a new church, Christ Church, and involved themselves in other good works such as school buildings and halls. His descendant, Sir Arthur Hallam Elton (1750–1842), was responsible for much of the current appearance of the town, having secured the land from the Clevedon Pill, in the south, up to the pier for the use of the townspeople. He was also instrumental in

improving living conditions through his work as chairman of the Local Health Board (which was established in 1853). The work of the board included the implementation of a proper sewage system (previously many households had emptied their refuse into open ditches), and the establishment of a waterworks company in 1863, which ensured clean water was available for local residents. Sir Arthur's other contributions to the wellbeing of Clevedon included the donation of 3 acres of land for the communal Herbert Gardens, the installation of gas lighting in the streets in the 1860s and the building of the Cottage Hospital in 1875. Sir Edmund Harry Elton (1846–1920) continued the good work and introduced the town to the Arts and Crafts Movement (he was a well-known potter whose distinctive Elton Ware can be seen on the clock tower in the centre of town).

Clevedon has other notable links to the arts world, with a number of literary figures associated with the town. Most notable are Samuel Taylor Coleridge, who rented a cottage on Old Church Road for several months in 1795, and reminisced about Clevedon in his poem, 'Reflections on Having Left a Place of Retirement', and Alfred Lord Tennyson, whose close friend Arthur Hallam is buried in St Andrew's church. Hallam's early death was to have a profound effect on Tennyson and influence some of his best known poems, including 'In Memoriam A. H. H.' William Makepeace Thackeray was also a frequent visitor to Clevedon Court.

By the mid-nineteenth century, Clevedon was prospering. The population had grown to around 2,000 people, with wealthy Bristolians moving into Georgian and Victorian villas near the seafront and merchants and traders setting up to cater for the burgeoning number of holidaymakers. The construction of the esplanade and seafront began in the 1830s, and soon hotels (such as the Royal Pier) and boarding houses were appearing. Visitor numbers increased when the Yatton railway line opened in 1847, linking Clevedon to the Bristol to Exeter railway network. The construction boom continued with Victorian houses and terraces spreading up the hillside and down to the flatter land to the south. New churches, schools, shops and a market hall duly followed. In 1869, the Clevedon Pier opened on Easter Monday, symbolising the prosperity of the town. Now visitors could catch steamers from the end of the pier down to Devon, across to South Wales and up the Bristol Channel.

As with all other English seaside towns, Clevedon's popularity as a holiday resort diminished in the latter part of the twentieth century. The emergence of cheap airline flights in the 1960s meant that more people were jetting off to the Mediterranean rather than dipping their toes into the chilly waters of the Bristol Channel. The lines of charabancs that transported factory workers and Sunday schools on their annual days out from nearby metropolises have long since ceased, and the loss of Clevedon's railway network connections (the Western, Clevedon & Portishead Light Railway closed in 1940 and the Yatton line in 1966) have added to the problem. However, Clevedon's history, architecture, community spirit and natural beauty, along with its advantageous location (Bristol is only 10 miles away and the M5 is on the doorstep) mean that it remains a very desirable place to live.

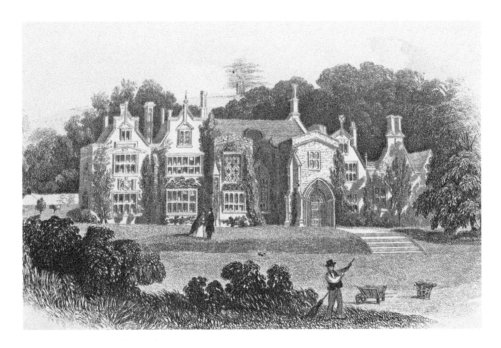

Clevedon Court, Nineteenth-Century Etching

Lying on the side of Court Hill, about a mile away from the centre of town to the west, Clevedon Court dates back to the 1320s, when it was built for Sir John de Clevedon, Lord of the Manor of Clevedon. It was altered over the years: the great hall and chapel block are early surviving parts of the building, while the west wing was a late sixteenth-century addition. From 1709, the Court has been home to the Elton family. The Court is a Grade I listed building, while the gardens are designated Grade II* (it is interesting to note the difference in the lawn's appearance in the etching and today).

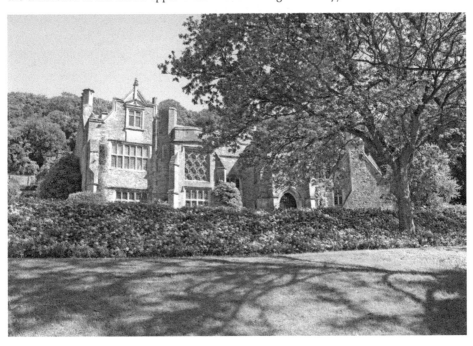

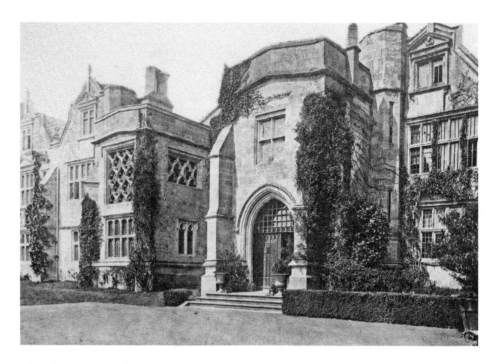

Clevedon Court, Early 1900s

Today the Court is managed by the National Trust, having been donated to the nation in 1960, although members of the Elton family are still in residence. As explained in the introduction, the Elton family played a key part in the development of Clevedon in the past two centuries. The Court is open to the public, who can also enjoy the eighteenth-century terraced garden and a fine collection of Nailsea glass and Elton Ware pottery, the creation of Sir Edmund Elton.

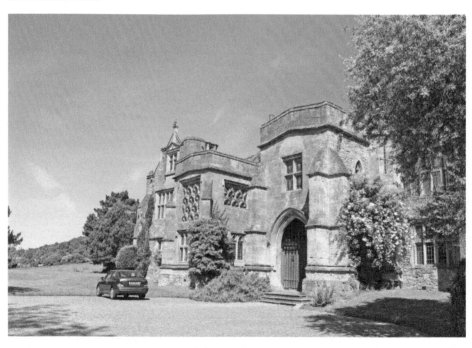

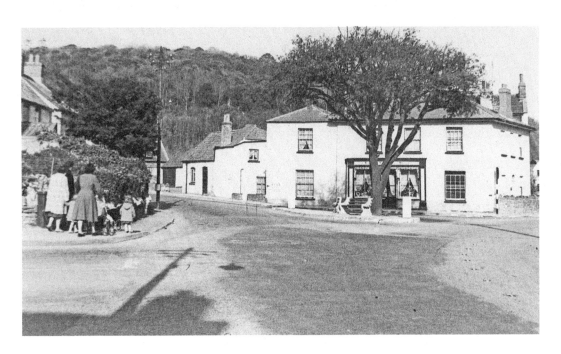

East Triangle, c. 1950s

This photograph shows the East Triangle roundabout with its distinctive Holm oak tree outside what has been a hairdressing salon for many years. Looking north up the B3124 Walton Road, the Old Inn can be seen in the modern picture. In the early nineteenth century, Chilcott's *New Guide to Clevedon* described the public house as 'bearing a very unpretentious exterior, and appropriately called "The Old Inn" [it is] almost the only place in the village where entertainment could be obtained for man and horse'. Today, this is a busy junction with roads leading to Portishead and towards Bristol (via the Tickenham Road).

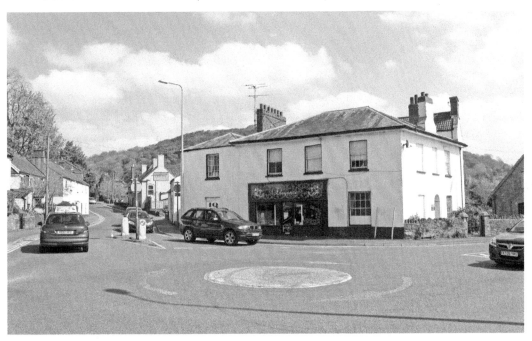

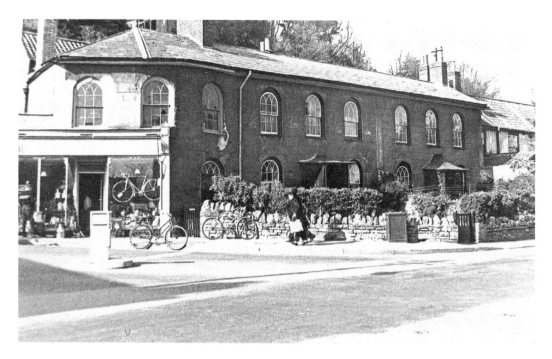

East Triangle, c. 1950s

One of the first building developments in Clevedon took place here when a local man, William Hollyman, converted two small cottages on East Triangle into Ilex Cottage, a small Georgian house (the name probably derives from the Holm oak, *Quercus ilex*). Over the years, the shop on the left sold furniture as well as bicycles, and was used as an office. East Triangle had a small number of shops, including a little post office and store across the road (run by Mr Basford in the 1950s).

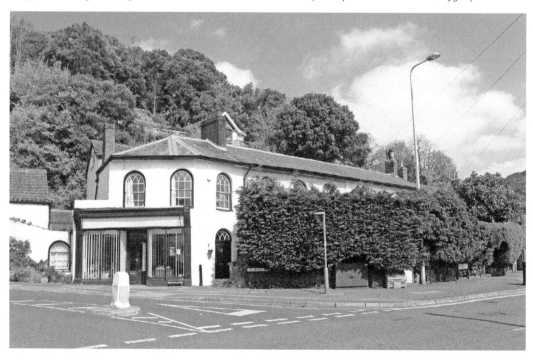

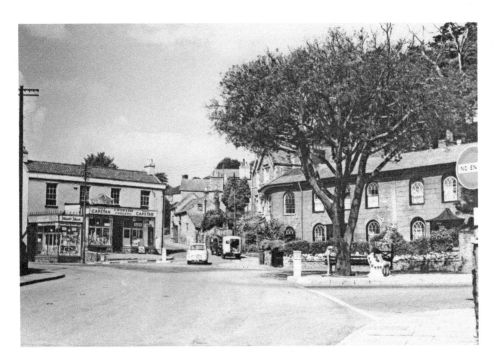

East Triangle, *c.* 1950s

With the cottages on the right now hidden behind a hedge and the oak tree removed from the busy junction, this image has altered quite considerably in the last sixty years. Bristol House (the shop facing the camera on the corner with Highdale Road) was a grocer's run by S. Dyer & Son and is advertising Oxo and Capstans in the window. In the past it has also been a second-hand furniture store selling items from house clearances.

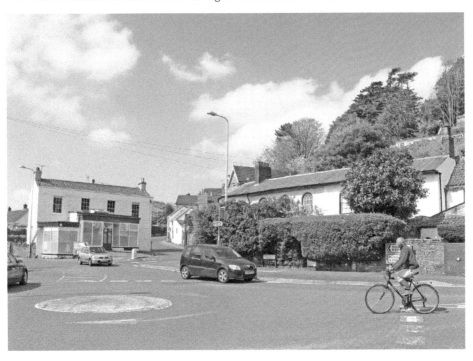

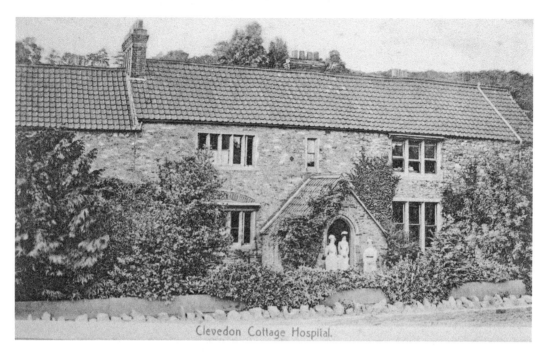

Clevedon Cottage Hospital.

Cottage Hospital, Old Street

The Cottage Hospital lies on Old Street (the B3130) at the eastern end of the town. The building was originally a barn in the lower farmyard of Highdale Farm. It was another donation by the Elton family of Clevedon Court (and part of Sir Arthur Hallam Elton's plan to improve the health infrastructure of the town), and was opened in 1874. It accommodated eight patients and was supported by voluntary contributions. Today, it sits alongside the North Somerset NHS Clevedon Hospital, with the Health Care Centre and Minor Injury Unit located next door.

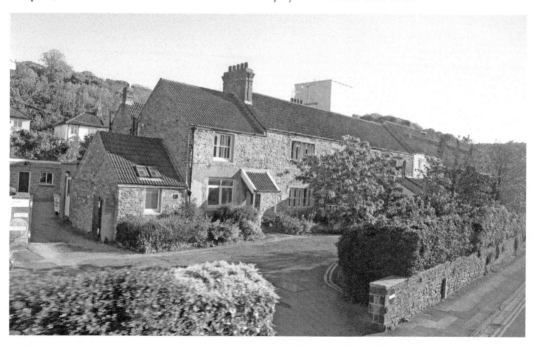

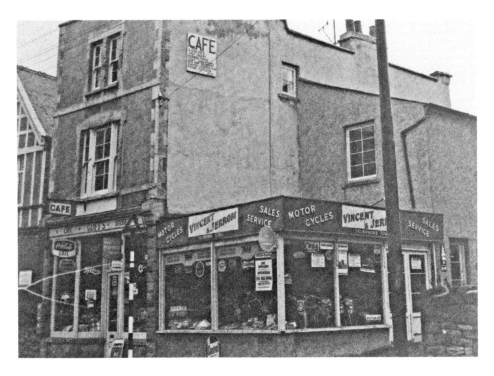

Old Street Shop, 1965

Further down Old Street from the Cottage Hospital, on the way towards the town centre, stood Goff's café and store on the left and Vincent & Jerrom's motorcycle shop on the corner. The café provided lunches, hot snacks, coffee, teas, sandwiches and bed and breakfast (parties were also 'catered for'), while Vincent & Jerrom's sold motorbikes, spare parts and offered servicing.

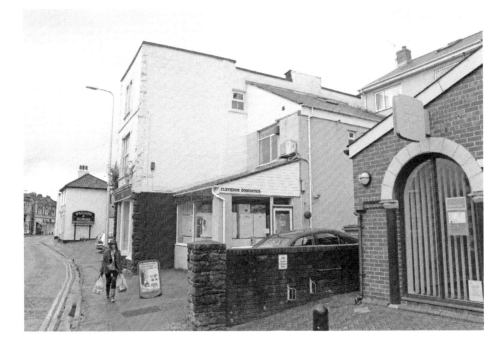

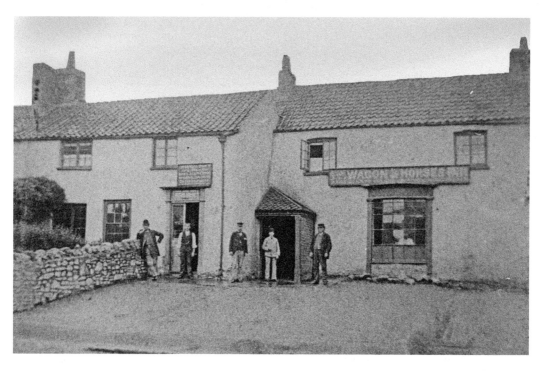

Waggon and Horses, Old Street, *c.* 1890s
Next door to what was Goff's café is the Waggon and Horses, at No. 20 Old Street. Today it is a red-brick building described as 'an unspoilt traditional community pub in the centre of Clevedon'. The only noticeable similarity in the two images is the large forecourt outside the entrance. The original pub was rebuilt in around 1905.

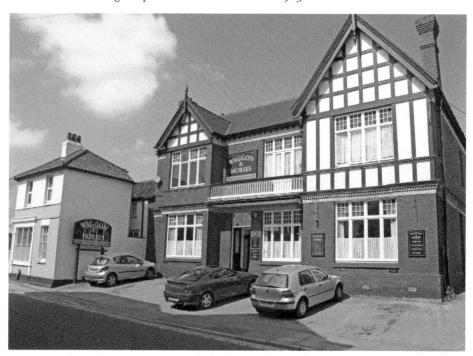

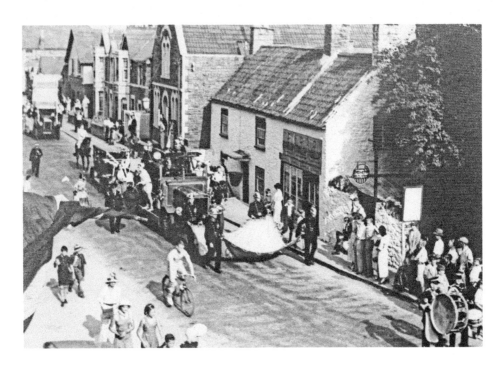

Old Street Parade, *c.* 1930s

Looking up Old Street, on the opposite side of the road to Goff's café towards East Triangle, we see the local fire brigade parading towards the town centre (the brigade is based on Old Street). Members can be seen carrying a safety net in front of the lead vehicle. The building in the centre of the picture (once a fish and chip shop) has been demolished and a new accommodation block has recently replaced it. Just beyond this is the Clevedon Salvation Army building, at No. 37 Old Street. To the right of the modern photograph is a bicycle shop.

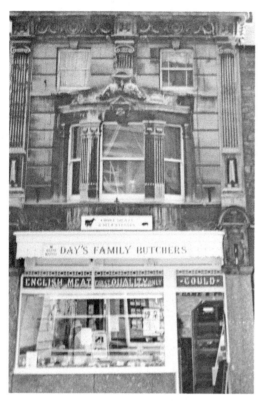

Old Street, Day's Family Butcher's, 1970s
Situated on the corner of Old Street and
The Triangle, this butcher's was run by the
Gould family for much of the twentieth
century. Herbert George William Gould
inherited the business in the 1920s from
his father George, a master butcher who
had taken over the premises in 1895.
It was George who was responsible for
the decorative interior tiling and the
impressively ornate exterior of the shop
(he ordered it from a company offering a
kind of catalogue selection of shop façades).
Herbert retired in 1962 and the shop was
taken over by Jim Marsh and his wife and
then, briefly, by Mr Day (as seen in this
photograph). Today, Poppy's café can boast
having probably the most imposing shop
front in Clevedon, thanks to George Gould.

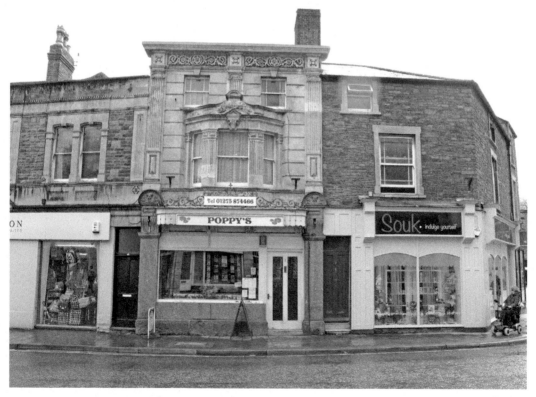

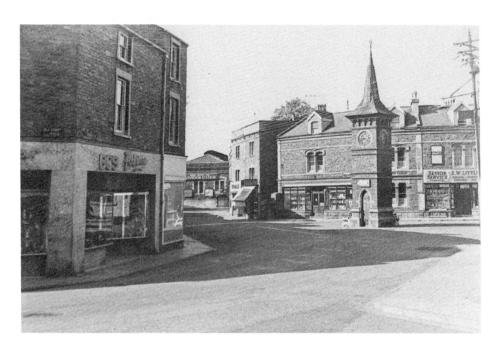

Clock Tower, The Triangle, 1950s

At the town centre stands the iconic Clock Tower in The Triangle (which is not to be confused with East Triangle). It was given to the town in 1898 by Sir Edmund Elton to commemorate Queen Victoria's Diamond Jubilee. It is now a Grade II* building. In these images we are looking west, with the junction with Old Church Road on the right in the modern picture. Behind the tower, in the old photograph, R. W. Little's store is advertising Senior Service and Capstan cigarettes. This row of shops was built on Rose Cottage. To the left, the old Great Western Railway station can be seen in the background.

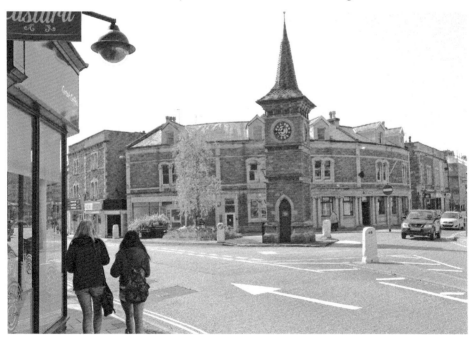

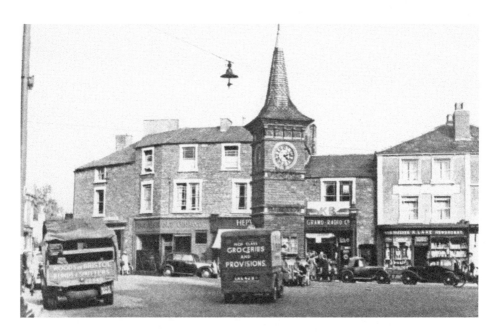

Clock Tower, The Triangle, 1950s

These images are looking east towards Old Street. Originally, the Clock Tower stood alone in the centre of The Triangle (at one time benches were placed beneath it but they have been removed). In this mid-1950s scene, Hepworths (a gentlemen's clothing shop) is behind the tower and a radio shop is to the right. By the 1970s, these had been replaced by, respectively, C. J. Hole estate agents and Jet Shoes. By then a branch of Mountstevens, the baker's, had opened on the left-hand corner where Rhubarb and Custard are now.

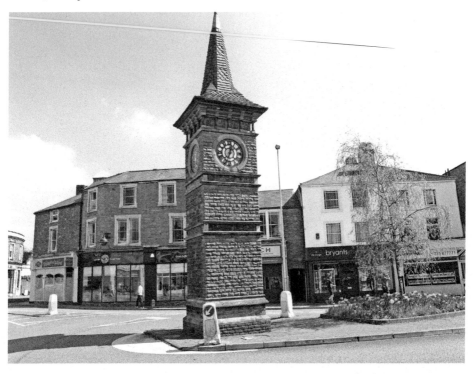

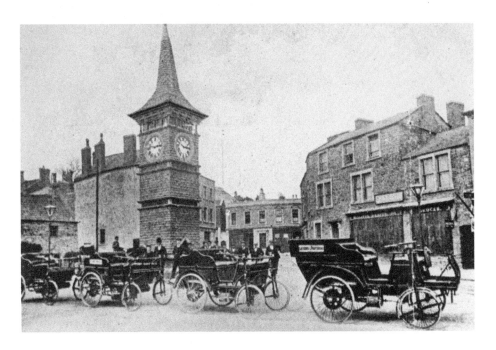

Clock Tower, The Triangle, 1903

The sides of the Clock Tower have differing façades (one has a horse trough, while another has a door entrance and other two are plain). The tower is decorated with Elton Ware pottery tiles, a style made famous by Sir Edmund Elton. He also donated a medallion of the head of Father Time, which is to be found on the northern side. The photograph above comes from the early years of motoring and shows vehicles built by local engineer and cycle builder R. J. Stephens. The solid wheels on the cars and the relatively poor conditions of the roads must have made for an uncomfortable ride.

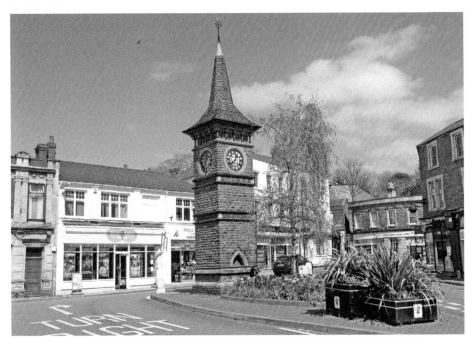

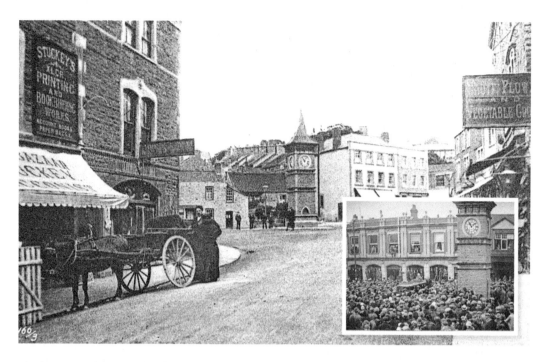

Clock Tower, The Triangle, 1900s

The Triangle has not only been a place for retail, it has also acted as a social gathering point. On the right-hand side of these pictures is the Conservative Club, and to the left of the Clock Tower (next door to Specsavers) is the Triangle Club, which was formerly the Liberal Club. Both clubs opened in 1892. In the inset, the politician David Lloyd George is addressing a crowd on 26 January 1926 to muster support for Mr Murrell, the Liberal candidate for Weston-super-Mare.

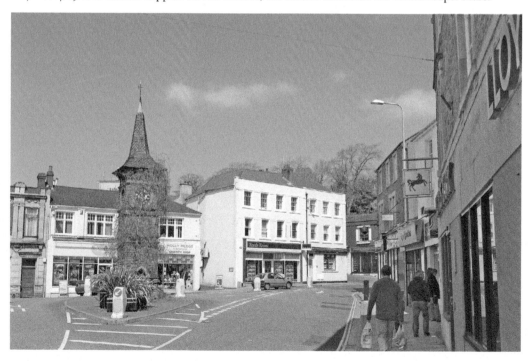

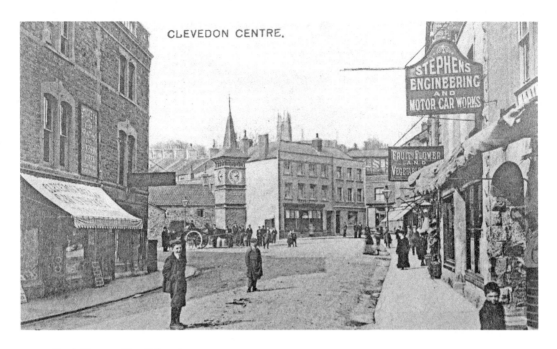

CLEVEDON CENTRE.

Clock Tower, The Triangle, 1900s

The shop sign advertises Stephens Engineering and Motor Car Works. At the turn of the twentieth century, Clevedon-based Richard Stephens was a pioneering automobile manufacturer. He used his knowledge of cycle building to produce a six-seater vehicle, affectionately known as 'the 1898 dogcart', which was used for public transport. Further vehicles followed and residents could ride up to Portishead for a fee of 2s each. The construction of the railway on the same route would put an end to the service. Just along from Stephens Engineering is a sign for a fruit, flower and vegetable shop that was owned by Gullifords.

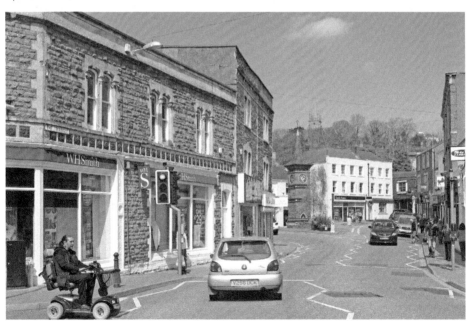

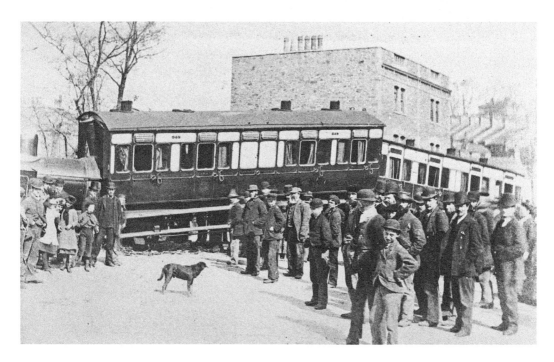

Railway Accident, 1881

The Yatton to Clevedon GWR link and the Weston, Clevedon & Portishead Light Railway (WCPR) may have improved transport to the town, but, as can be seen in this picture, they were not without their problems. A rather bemused looking dog is standing in front of a train that has been derailed from its line (which passed across the modern road). The WCPR line was particularly erratic; it had mostly second-hand rolling stock from South America and had nineteen stopping points (often without proper platforms) on its 13.8-mile route from Weston to Portishead.

Railway Car Park, 1980s

Looking across the site of the defunct Yatton line railway station and car park towards the north of the town, this before-and-after sequence is a good demonstration of how Clevedon has revitalised itself. Queen's Square is now an attractive shopping precinct with an open space area. The large supermarket (now owned by Morrison's) was designed to complement the existing architecture of the surrounding buildings. To the left is the new Baptist church building, while on the skyline of the mid-1980s photograph the spire of Christ Church can be seen looking out over the town centre.

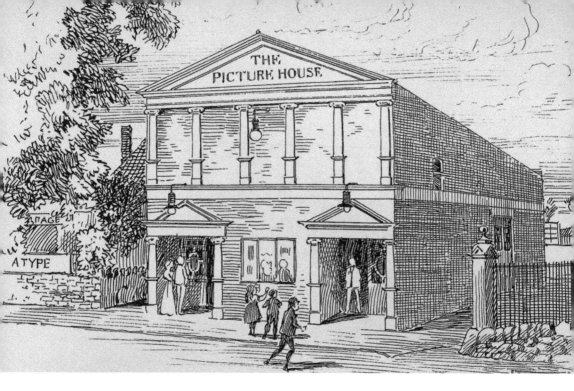

Curzon Community Cinema, Old Church Road, 1900s

The Curzon Community Cinema is one of the oldest continuously running cinemas in the world. The purpose-built building first opened its doors on 28 April 1912, and its first screening was a fundraiser for victims of the *Titanic* disaster. Mr Cox's original building was extended in the early 1920s. Its brick and stonework exterior stretches over six shop fronts, and an Art Deco sunrise encircling the venue's name in neon letters stands above the main entrance. The auditorium walls are lined by ornamental pressed tin tiles (which are said to improve the acoustics). The Curzon witnessed Clevedon's only fatality during the Second World War when a soldier standing in the doorway was struck by a bomb during an air raid. The shrapnel damage can still be seen on the cinema's exterior wall.

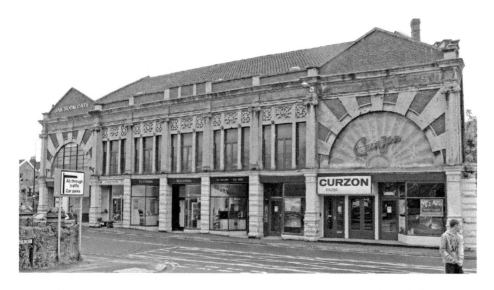

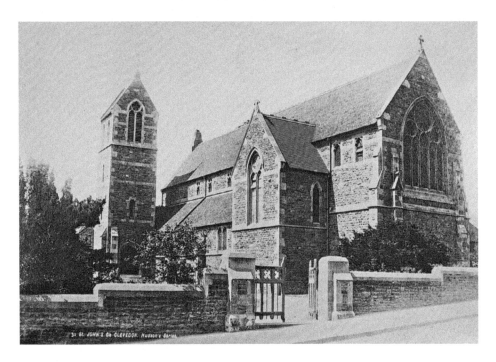

St John's the Evangelist, St John's Road, 1900s

Designed by William Butterfield and dating from 1875/76, St John's was built for Sir Arthur Elton in memory of his late wife, Dame Rhoda. It has a robust Gothic Revival-style exterior with rock-faced stone walls with stone dressing. It also has a rose window to the north transept and a plain tile roof. The church is a Grade II* building. The images here are taken from Queen's Road.

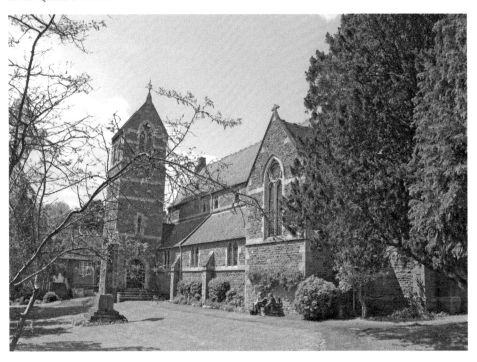

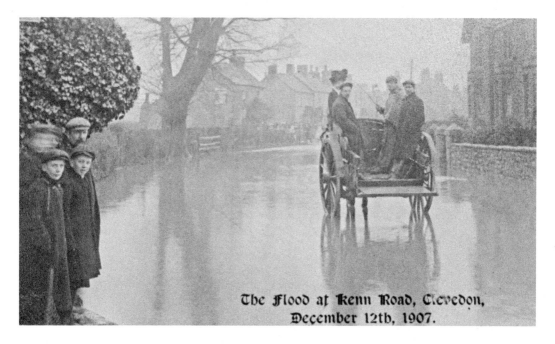

The Flood at Kenn Road, Clevedon, December 12th, 1907.

Kenn Road, 12 December 1907

Stretching down towards Yatton, Kenn Road is one of Clevedon's oldest roads. Originally built as a dyke to help drain the low-lying land, by the eighteenth century it was a rough road lined with a few farm workers' cottages and buildings. Today, it runs through Clevedon's modern housing development to the south. As can be seen in this photograph from 1907, Kenn Road was still prone to flooding before an effective drainage system was employed in the last century (including the culverting of the Middle Yeo in the 1970s).

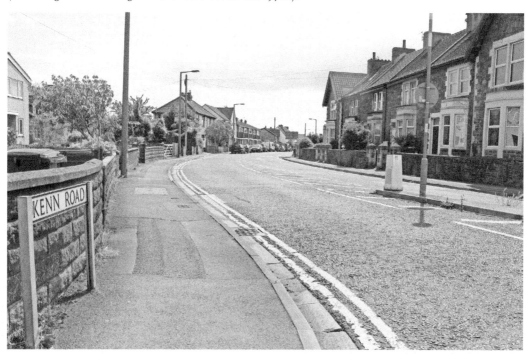

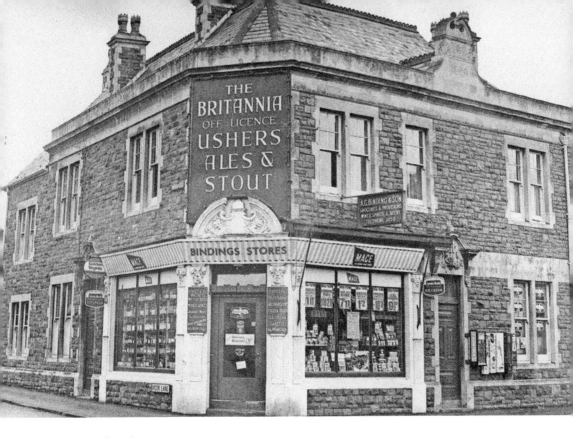

Kenn Road, 1960s

Taken at the corner of Kenn Road and Moor Lane, these photographs show how some parts of Clevedon have altered over the years. A. G. Bindings & Son's store, with its attractive exterior stone carvings, has been demolished, and the junction between Kenn Road and Moor Lane widened to give the ever-increasing flow of traffic easier access to the nearby M5 motorway.

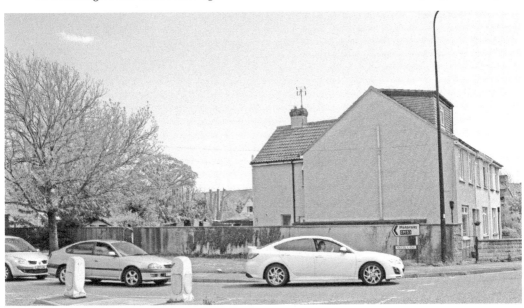

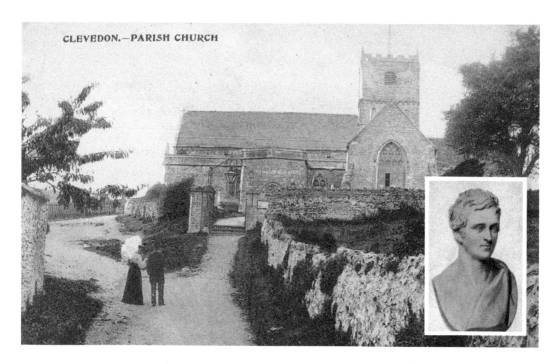

St Andrew's Church, 1900s, and Bust of Arthur Hallam (*Inset*)
Also known as the 'Old Church', St Andrew's was built in the twelfth century on Anglo-Saxon foundations. Sited on a headland overlooking the Bristol Channel, the parish church is at the western edge of the town, approximately 2 miles from Clevedon Court. The manorial chapel of the Lords of Clevedon at St Andrew's holds the vaults of the Elton and Hallam family. Sir Charles Elton's sister, Julia, married into the Hallam family and was the mother of Arthur Hallam, Alfred Lord Tennyson's close friend.

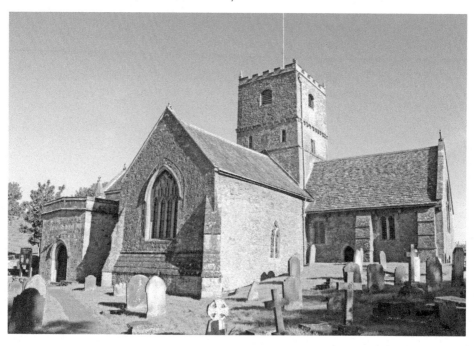

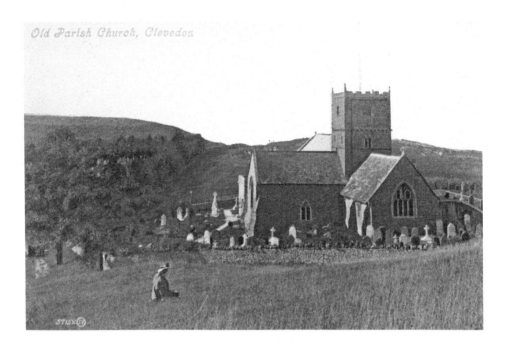

Old Parish Church, Clevedon

St Andrew's Church, 1900s

The poet laureate Alfred Tennyson did much to bring Clevedon to the attention of the Victorian public, in particular through his popular elegy 'In Memoriam A. H. H.', which details his emotional and spiritual turmoil at the early death of his friend, Arthur Hallam, in Austria: 'The Danube to the Severn gave, / The darken'd heart that beat no more; / They laid him by the pleasant shore, / And in the hearing of the wave. / There twice a day the Severn fills; / The salt sea-water passes by, / And hushes half the babbling Wye, / And makes a silence in the hills' (XIX). Tennyson was so distraught by Hallam's passing that it took him seventeen years before he could bear to visit Hallam's resting place.

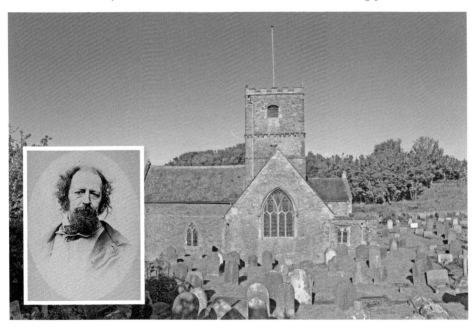

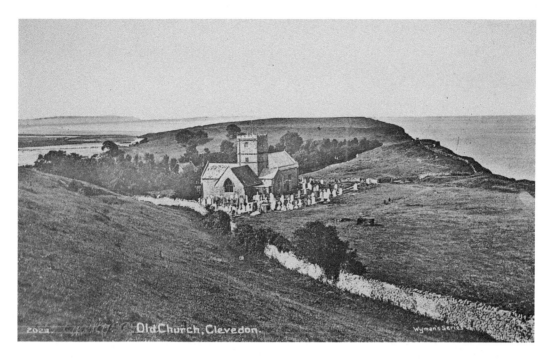

St Andrew's Church, 1900s

Looking south-west towards Wain's Hill, these views of St Andrew's emphasise the rather remote nature of the parish church. It is, however, the ideal location for the Poets Walk, which runs behind the church along the side of the headland and past Church Hill. St Andrew's is still an active and important church in the community, as can be seen by the growth in the size of the churchyard (there is limited consecrated ground in Clevedon town itself).

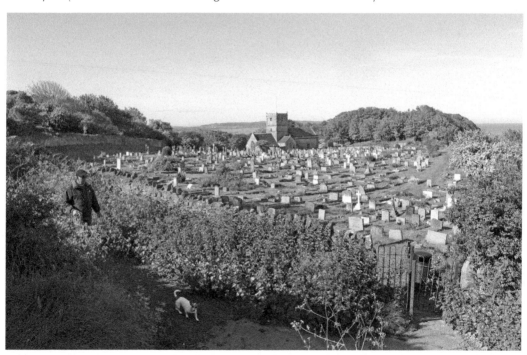

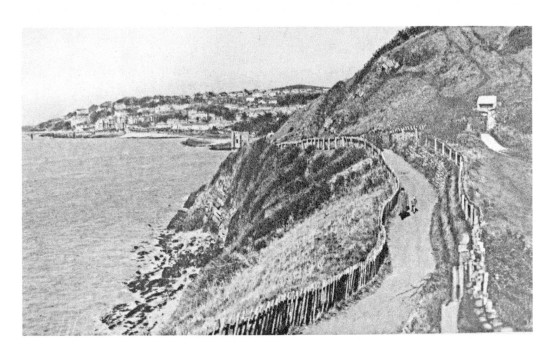

Poets Walk and Salthouse Point, 1950s

Walkers seeking inspiration can follow in the footsteps of poets such as Coleridge and Tennyson and stroll along this path to the Lookout, and Salthouse Point, where they are rewarded with a fine vista over Salthouse and Clevedon bays and across the Bristol Channel to South Wales. In the inset is The Lookout, which was said to be used by the sugar importing Finzel family in the nineteenth century to watch cargo ships returning from the West Indies. Originally erected in around 1835 by Ferdinand Beeston, it was restored in 2006 by the Clevedon Civic Society, Yansec, North Somerset Council, Clevedon Town Council, John Gent and Michael Hale.

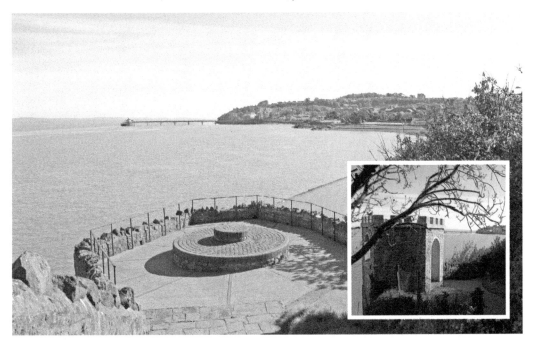

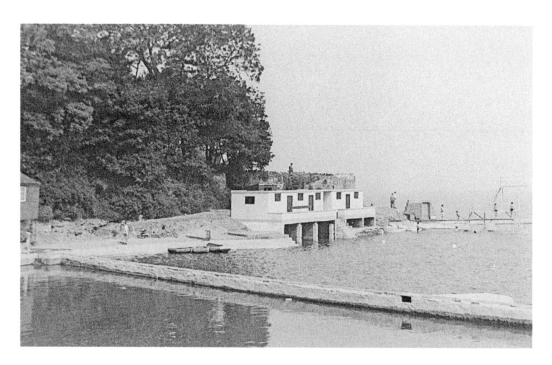

Marine Lake, 1960s

Popular now with model boat enthusiasts, the Marine Lake opened on 30 March 1929 and has been used since by hardy Clevedon residents who enjoy a cold water dip. The lake is deep enough for a triple-tier diving platform to have been used in the past but does silt up through mud being deposited when the tide flows over the wall. The old changing rooms can be seen in the top photograph.

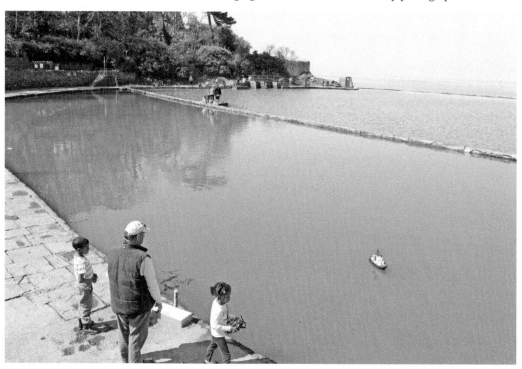

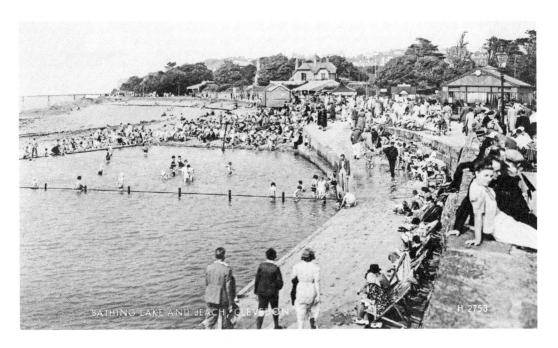

BATHING LAKE AND BEACH, CLEVEDON H 2753

Marine Lake, 1950s

During the Second World War, German prisoners of war were put to work building parts of Clevedon's sea wall defences (near Kingston Seymour). A selection of international flags is now flown along the seafront. Clevedon residents are eager to see the Marine Lake recapture its former popularity (seen here in its 1950s heyday). The voluntary group Marlens, which works to promote and maintain the lake, played a pivotal role in obtaining a National Heritage Lottery Fund grant for £800,000 in 2014 to restore the promenade, strengthen the sea wall, introduce a paddling area and provide improved access, which aims to increase water sports and attract visitors.

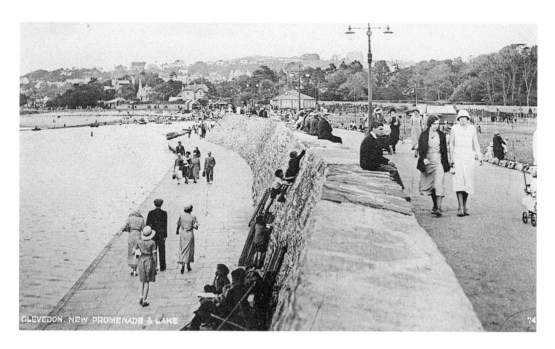

CLEVEDON. NEW PROMENADE & LAKE

Marine Lake, Mid-Twentieth Century
To the right of the promenade is the area known as the Salthouse Field, where farmers used to allow water from the Estuary through the sea wall, where it evaporated and then turned the residue into sea salt through a process of boiling. Today, the recreational garden area has a miniature railway track and is home to the Clevedon donkeys, which provide rides during the summer.

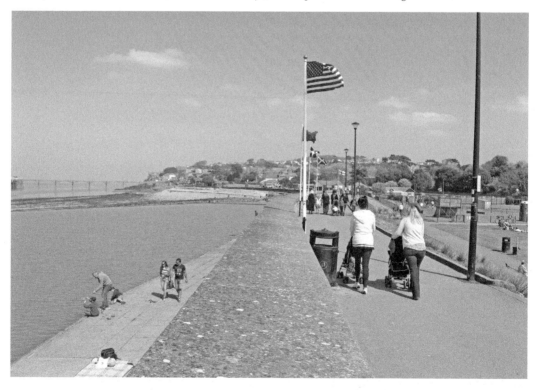

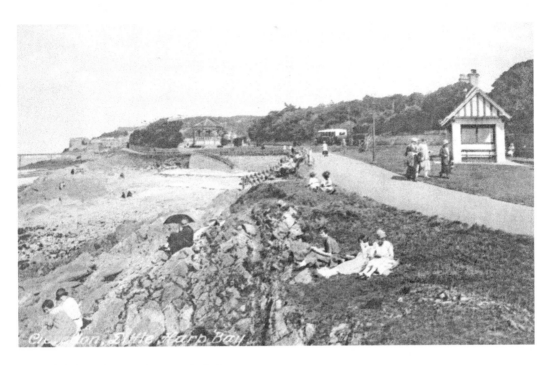

Littleharp Bay, Early Twentieth Century
This view of Littleharp Bay gives a good impression of Clevedon's shoreline, which is a combination of rocky outcrops and stony beaches. To the right is a Victorian shelter and in the middle distance is the Victorian bandstand. Passing along Elton Road is an early type of bus or coach.

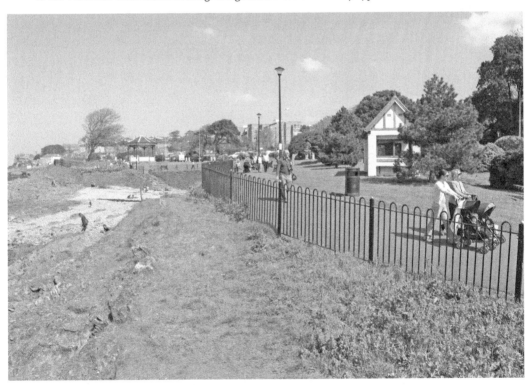

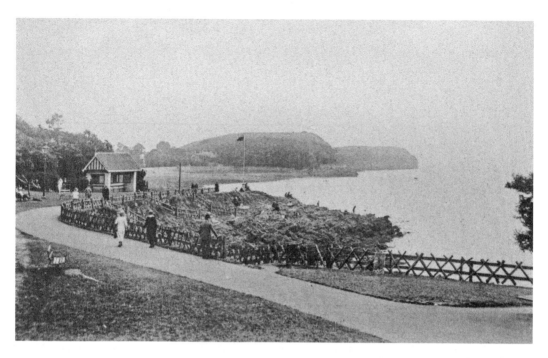

Littleharp Bay, 1920s

These images are taken looking back towards the Marine Lake and Wain's Hill. Note the lower wooden fence in the earlier photograph, which has been replaced by higher metal railings (no doubt conforming to modern-day health and safety standards).

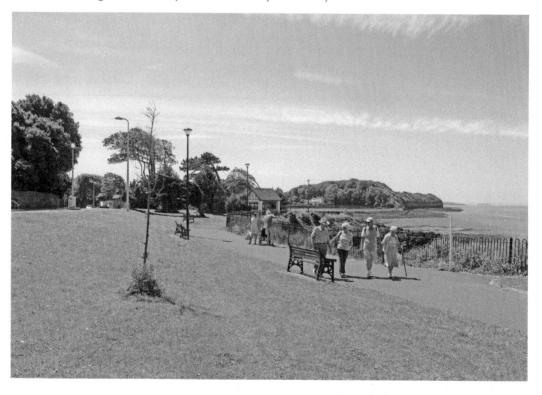

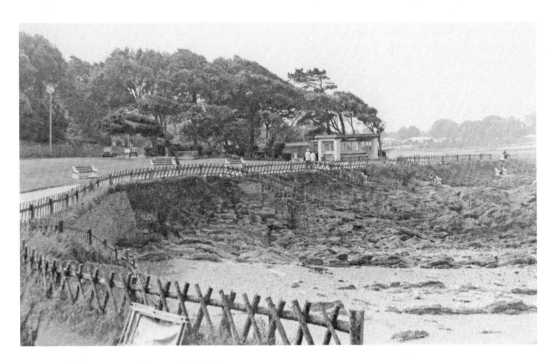

Littleharp Bay, Mid-Twentieth Century
The appearance of the shelter has altered; in the picture above it has a flat roof. Over the years, the shelter has been subjected to vandalism, though community youth programmes have reduced the problem in recent years. The roof has now been restored to its original design.

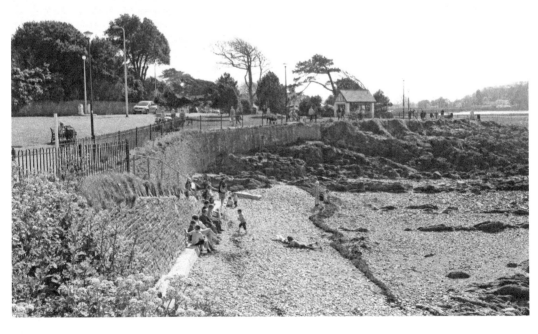

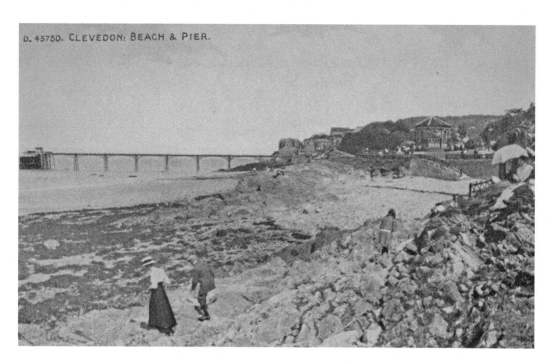

Clevedon Beach and Pier, Early 1900s

The lady on the rocks in the top picture seems somewhat overdressed for clambering over the slippery rocks on the foreshore. To her right, another Edwardian lady looks on under the safety of her parasol. The *Spirit of Clevedon* sculpture was erected in 2000 to celebrate the Millennium, and portrays the town's pioneering and community spirit 'through its forward pointing sail shape, port hole rings, plaques and panels'. Designed by local citizens, it has a time capsule within its base containing an assortment of artifacts, including a boundary map, photographs, essays and a directory.

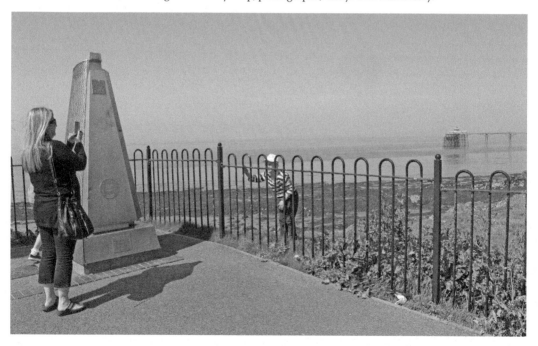

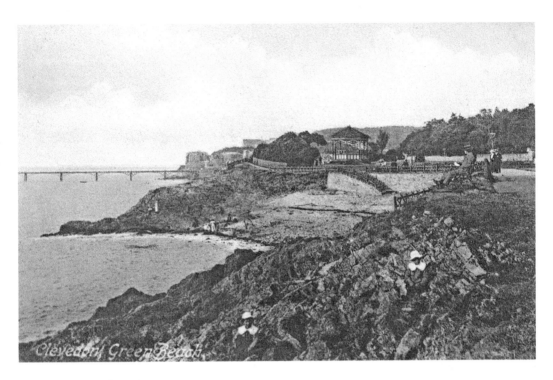

Green Beach, Early 1900s
The top panorama shows Green Beach at high tide. Children still enjoy clambering over the rocks, but it appears our Edwardian ancestors were more insistent on them wearing sun hats.

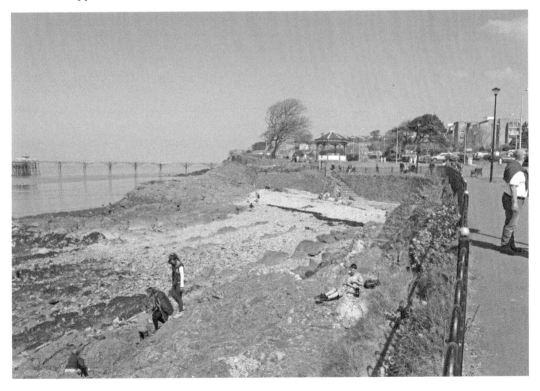

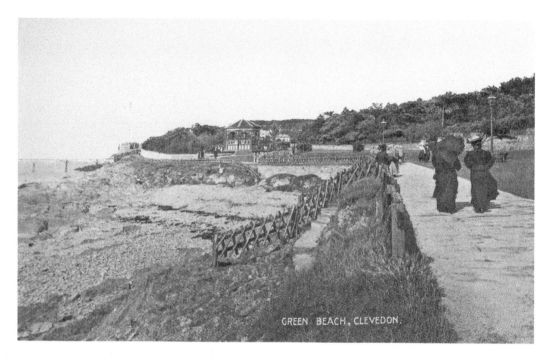

GREEN BEACH, CLEVEDON.

Green Beach, 1900s
This view looks across Green Beach towards the bandstand and the pier. The ladies in the long skirts are a reminder of how genteel promenading was in Edwardian days.

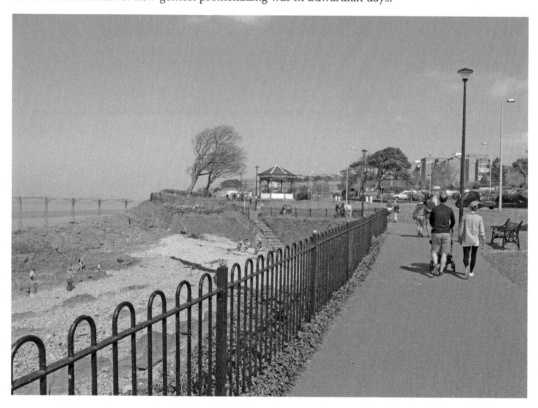

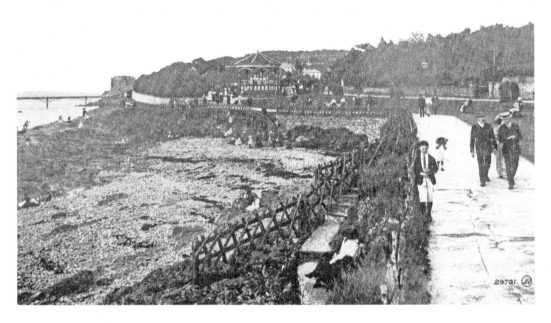

Green Beach, Early 1900s
Here a number of Edwardian families are enjoying the sea air on Green Beach and promenading along the front. The top of the town can be seen peeping out behind the bandstand.

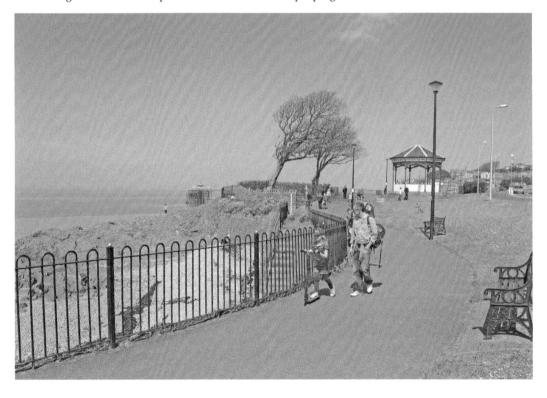

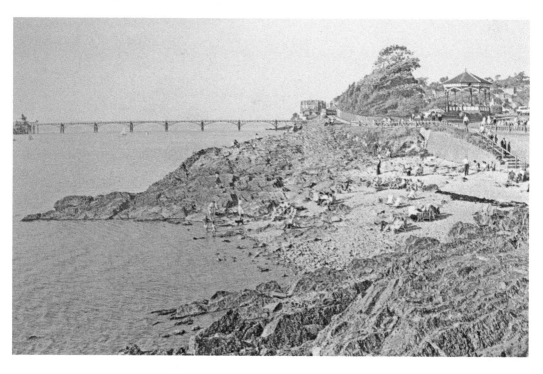

Green Beach, Early 1900s
Although taken from a similar spot to the previous page, it is worth noticing the difference that the Severn's famous tidal surge has made; more than half of the beach is now submerged.

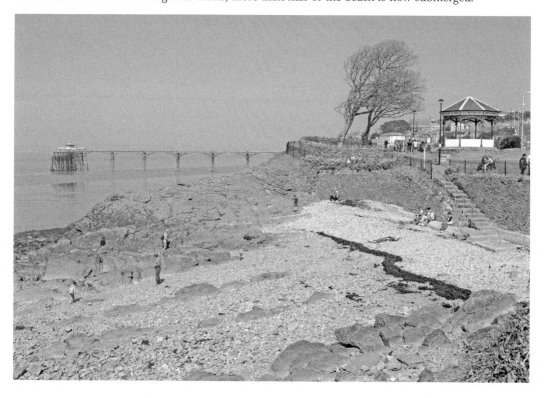

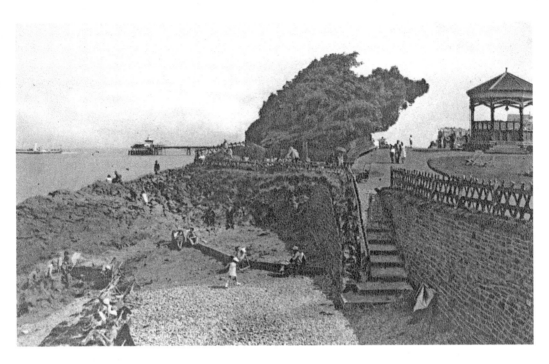

Green Beach, Early 1900s

Looking up to the bandstand, a paddle steamer can be seen just to the left of the pier. In the days when comparatively few people owned cars, a day trip to Ilfracombe in Devon or South Wales on a steamer was a much enjoyed treat.

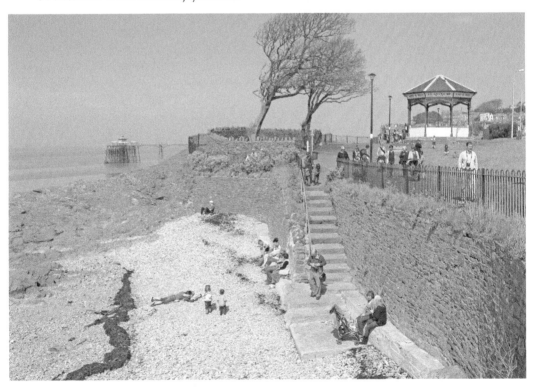

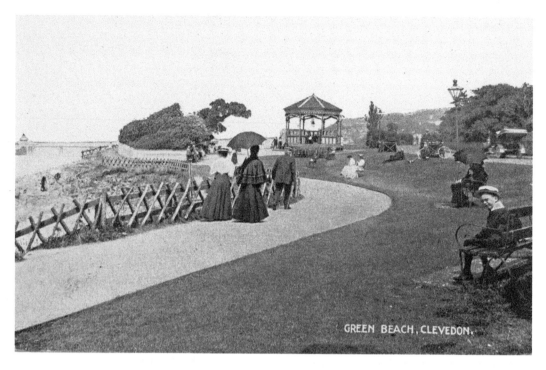

Green Beach, Early 1900s

Built in 1887 by William Green (who also built the Toll House at the entrance to the pier), the bandstand was lit by gas; in the old photograph an overhead lamp can be seen hanging in its centre. The steps on the left of the pictures lead down to Littleharp Bay.

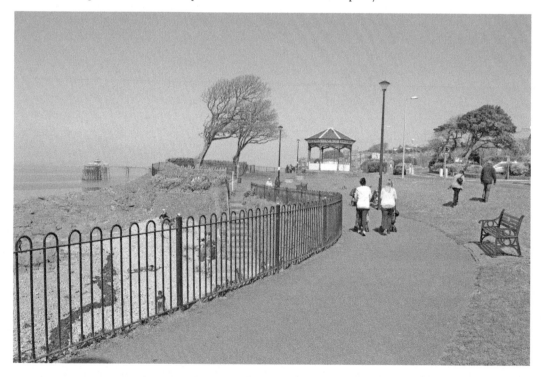

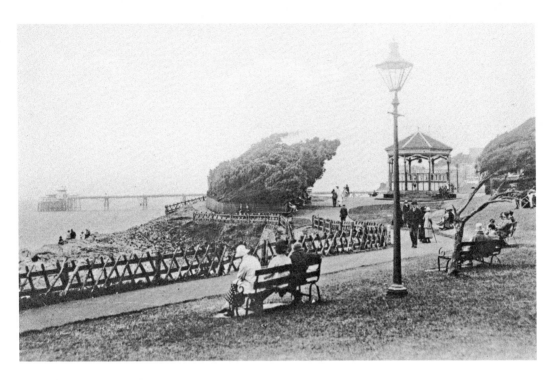

Green Beach, Early 1990s
Originally, the bandstand had no windshields: these were added later to protect bandsmen from the elements and improve acoustics. In the centre of the old picture is a fine Victorian lamp post, which stands out in contrast to its modern utilitarian replacement.

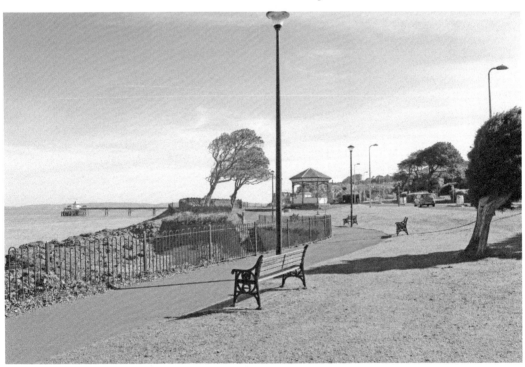

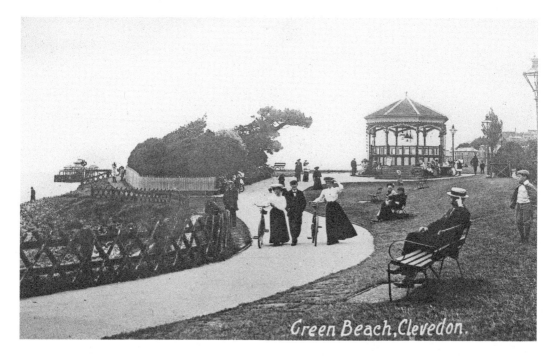

Green Beach, Clevedon.

Victorian Bandstand, Early 1900s

Here two Edwardian ladies are pushing their bicycles along the path (roller skating along the seafront was at one time also popular). The fenced area on the left (now walled with a flower bed in front) was known as the 'monkey walk' and described by a local resident as 'quite cosy'. It was a popular place where, in the 1950s, local boys would sit and wait for the girls to go by. Seats were placed within the walled enclosure.

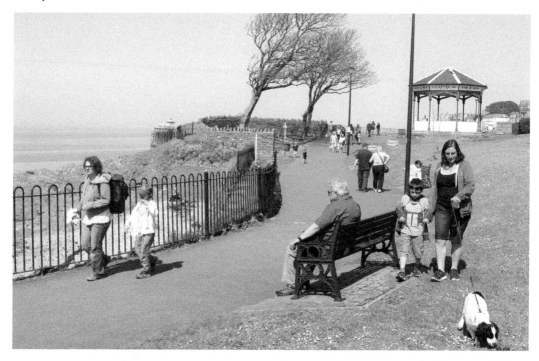

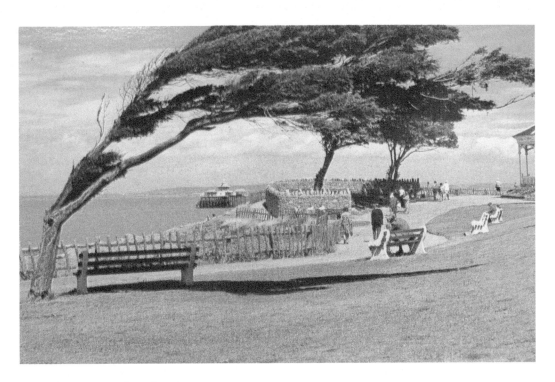

Victorian Bandstand, 1960s

The impressively bowed trees by Clevedon's bandstand stand testament to the strong winds that blow in from the Bristol Channel. They have featured in school geography textbooks as an example of the action of prevailing winds.

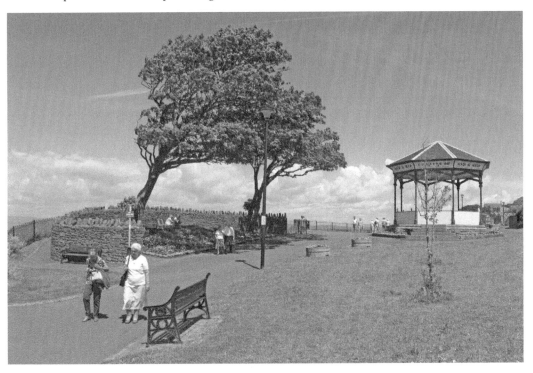

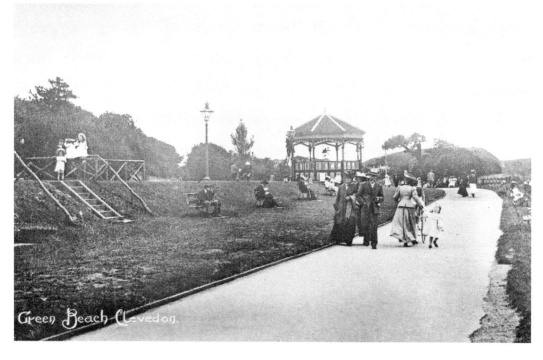

The Promenade, Early 1900s
Looking south (the shelter can be seen in the background in the bottom picture), the Edwardian family are walking past part of the ornamental gardens that are laid out along Clevedon's seafront promenade.

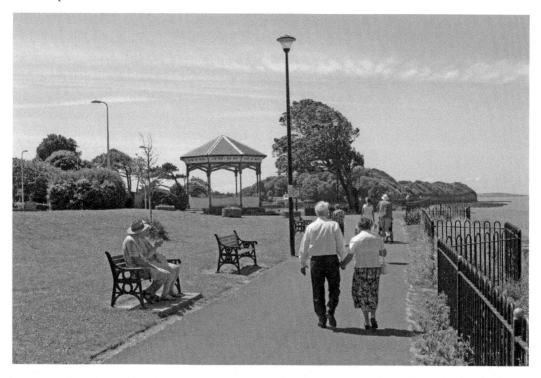

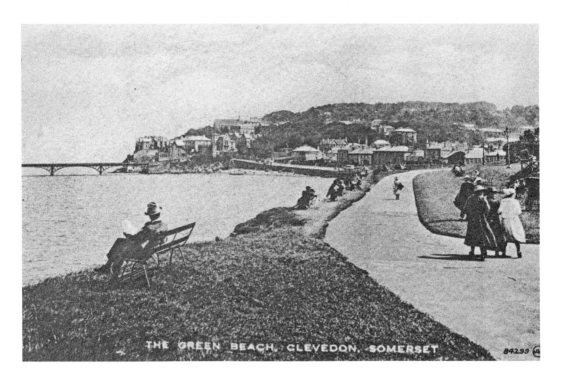

The Promenade, Early 1900s

This scene captures the elegant charm of early twentieth-century Clevedon. Still running alongside Elton Road, this part of what is known as The Promenade is north of the bandstand and runs towards the esplanade (also known as The Beach).

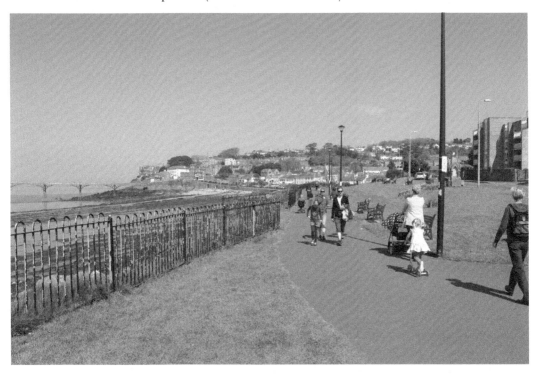

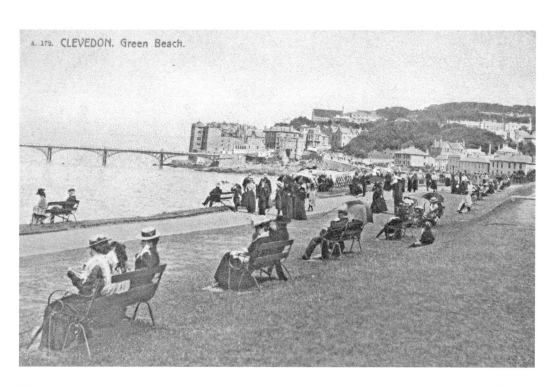

A. 173. CLEVEDON. Green Beach.

The Promenade, Early 1900s
This view shows how popular Clevedon seafront was in the early twentieth century. It was a place to 'see and be seen', and ladies and gentlemen dressed up accordingly.

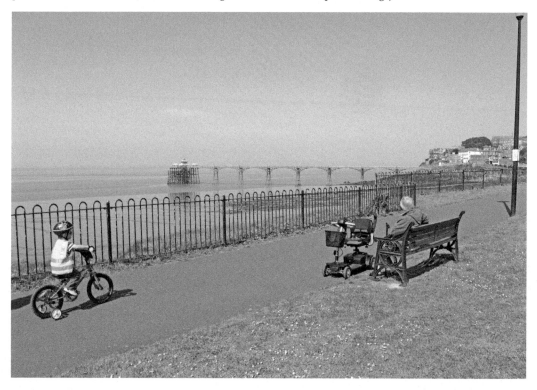

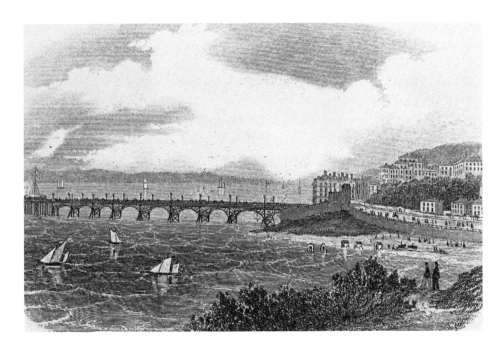

Clevedon Bay Engraving, 1869

This engraving, dated August 1869, shows Clevedon Pier months after its opening on Easter Monday, 29 March. Following a town meeting in 1866, the Clevedon Pier Company was set up to organise the funding and construction of the pier. Money was raised through the sale of shares, John William Grover and Richard Ward were the chosen engineers, Hans Price the architect and Hamilton's Windsor Ironworks Company were duly awarded the building contract in 1867. Approximately 370 tons of wrought ironwork were used, with recycled Barlow rail (discarded from Brunel's broad-gauge South Wales Railway) providing the supports for the pier. The total cost of the original pier was £10,000.

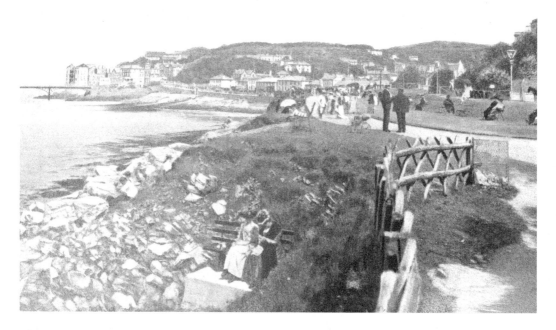

The Promenade, Early 1900s

Two Edwardian ladies with fine hats are sitting on a park bench on a small lookout point below the seaside path. Sadly, the bench has now been removed (the young boy in the modern photograph is standing on its foundations).

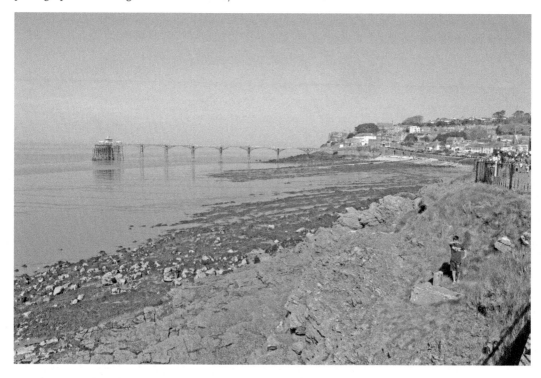

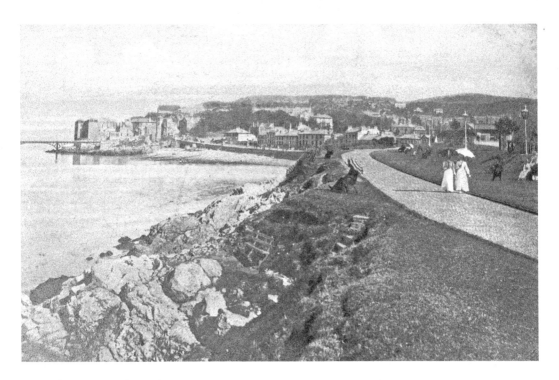

The Promenade, Early 1900s
Another reminder of the genteel pastime of promenading, popular in Edwardian days; here two ladies are protecting themselves from the sun under parasols as they walk along the path, while another lady shelters beneath hers while seated on a park bench.

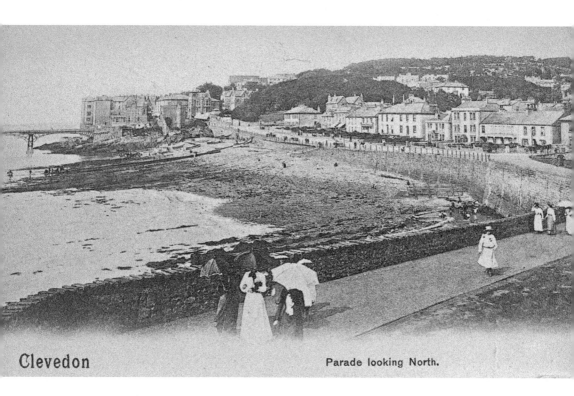

Clevedon

Parade looking North.

Overlooking the Esplanade, *c.* 1900
This part of the path leads down to the esplanade, which runs along the front towards the pier. In the distance, the last building on the left is the former Royal Pier Hotel.

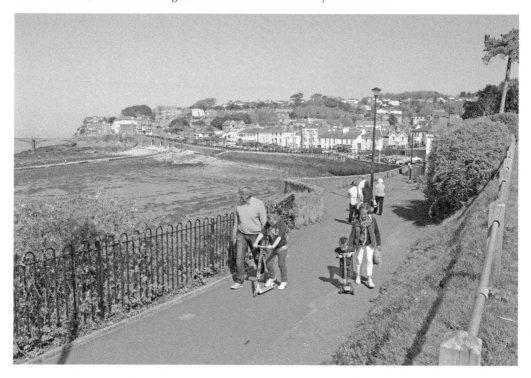

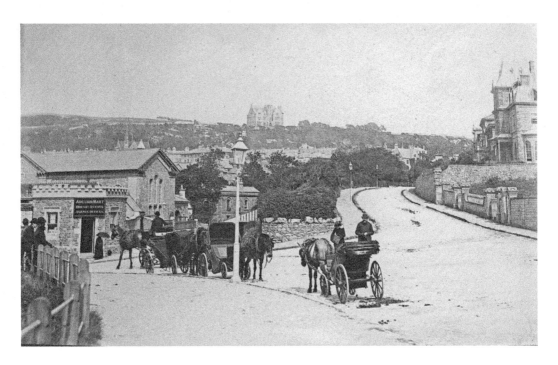

Elton Road, Late 1800s

These photographs are taken at the point where Elton Road continues to the right and the beach runs down to the seafront on the left. The Auction Mart and Estate Agents, run by Alonzo Dawes, was later occupied by a photographer, a small café and an ice cream parlour. The monument in the modern picture is a peace memorial for the dead of the South African Wars. The figures in the inset are observing a partial eclipse of the sun, which occurred on 25 August 1895.

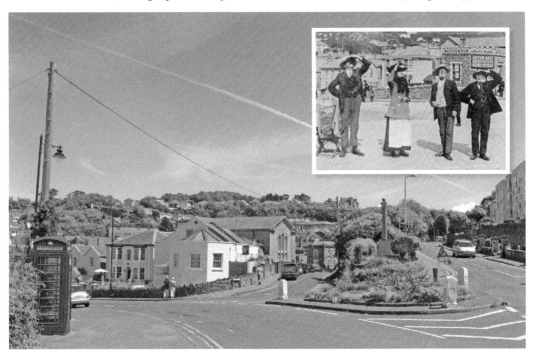

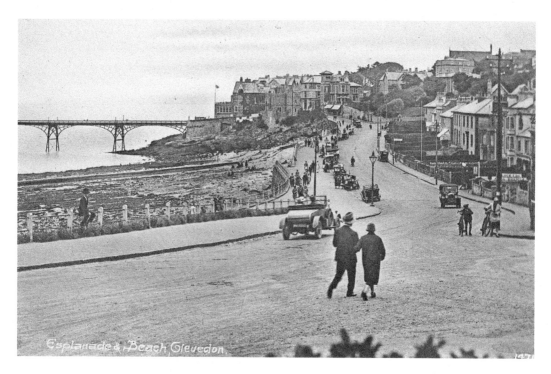

The Esplanade, Early 1900s

This photograph is taken at the top of Elton Road, looking north along the esplanade. Parking was clearly not a problem in the early years of car travel, although the state of the roads was still quite poor, judging by this picture. The modern photograph was taken on a busy Good Friday bank holiday.

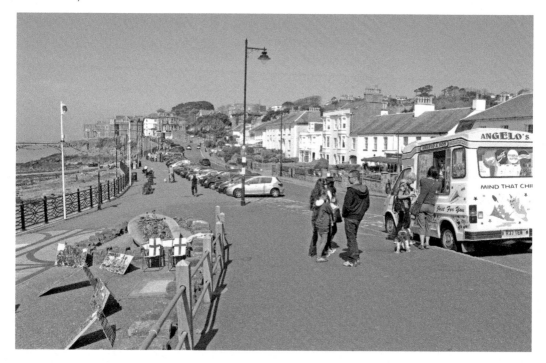

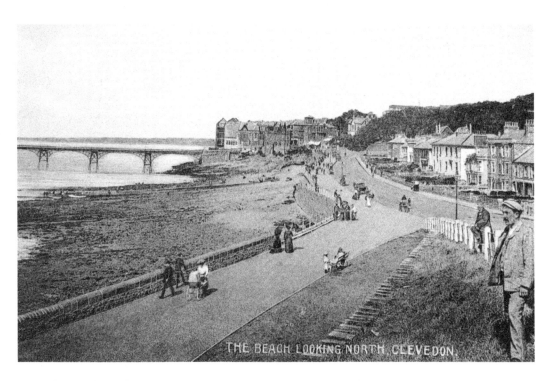

The Beach, Early 1900s

In the lower photograph are a number of small vessels. Sailing has been popular in Clevedon for a number of years and the sailing club has its headquarters on Marine Parade. It supports all water sports with emphasis on dinghy and cruiser sailing.

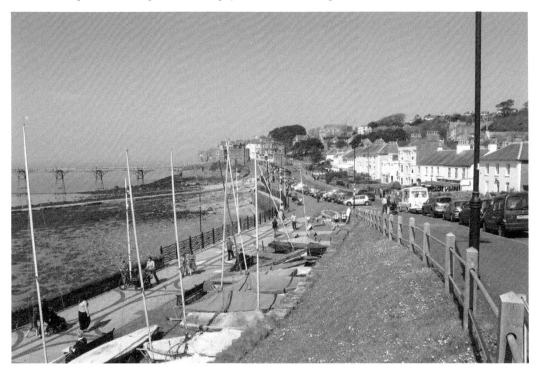

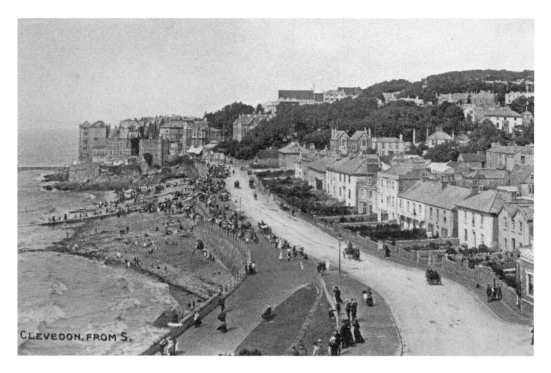

CLEVEDON, FROM S.

The Beach, Early 1900s

When comparing Clevedon past and present, one of the most striking aspects is that the town has managed to retain its historic charm. Many of the old buildings in these photographs are easily identifiable and have not fallen victim to gaudy exterior makeovers popular in many seaside resorts.

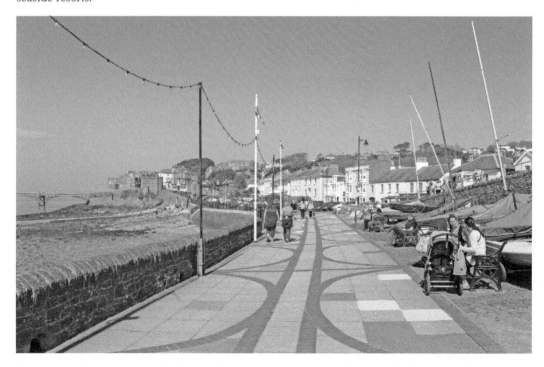

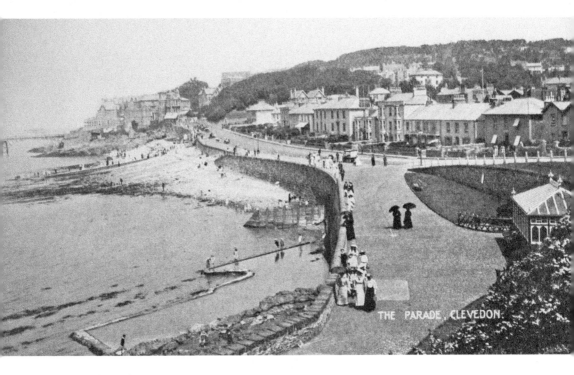

The Beach, Early 1900s

Peering over the sea wall, we can just make out the outline of the remains of the 'paddling pool', which can be seen in action in the Edwardian shot. It had gone out of use by the 1920s. The building on the right was used as an air-raid shelter during the Second World War, and is now the home of the Clevedon Sailing Club.

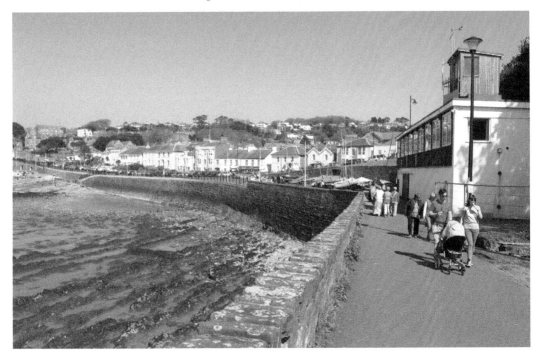

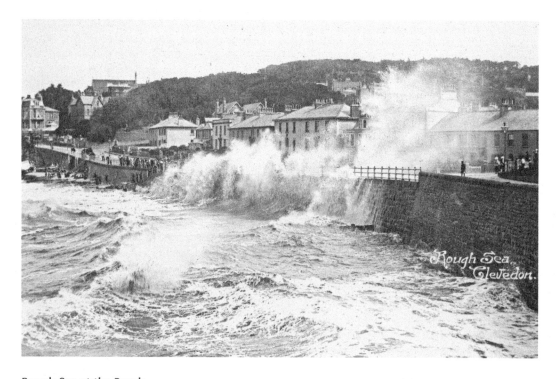

Rough Sea at the Beach

Besides pictures of the pier, the most common image of Clevedon is of storm waves breaking over the seafront. Although not a common occurrence, it is nevertheless dramatic, especially when compared with a photograph of the high sea wall at low tide.

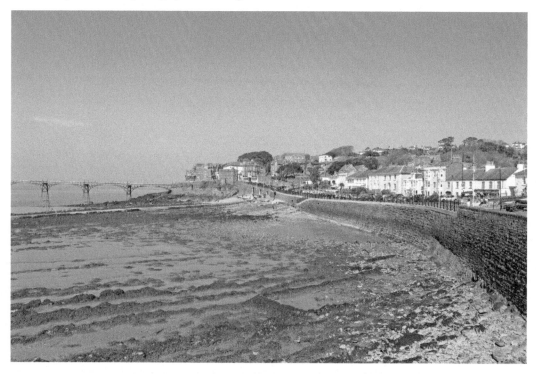

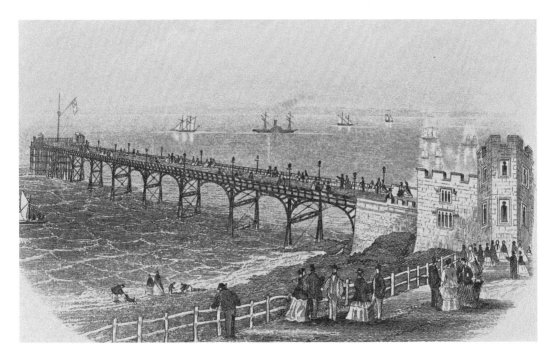

Clevedon Pier Engraving, *c.* 1870
Described by Sir John Betjeman as 'the most beautiful pier in England', Clevedon Pier is now a Grade I listed building. Stretching 312 metres into the Bristol Channel, the pier has eight arched spans, supported by steel rails covered with wooden decking, with a pavilion on the pier head. Ownership passed from the Clevedon Pier Company to the Local Government Board in 1890 (the cost of running the pier was prohibitive), and it was reopened in 1893 with a new pier head.

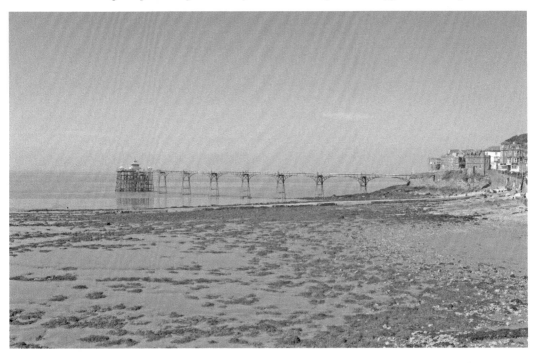

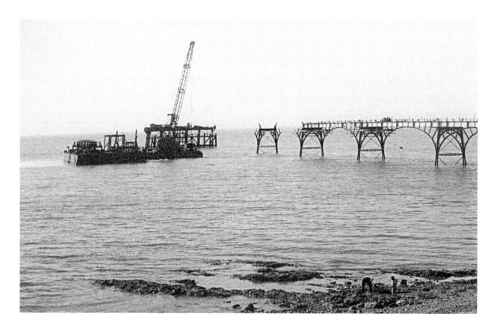

Dismantling Clevedon Pier, 1985

The fact that Clevedon Pier is one of the oldest surviving Victorian piers in the country is down primarily to the work of the Clevedon Pier Preservation Trust and the generosity of the town's residents. As seen in this photograph, the pier was in a parlous state in the 1980s; a load testing for insurance purposes in 1970 had resulted in the collapse of two spans. The following year, a public appeal was launched and the Pier Trust was established in 1972. Restoration began in the early 1980s and, in 1985, the pier was dismantled and taken to nearby Portishead Dock for rebuilding. The pier reopened to much celebration on 27 May 1989, and the restoration programme was completed in 1998 with the opening of the pier head.

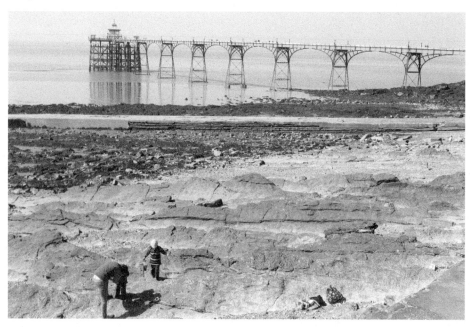

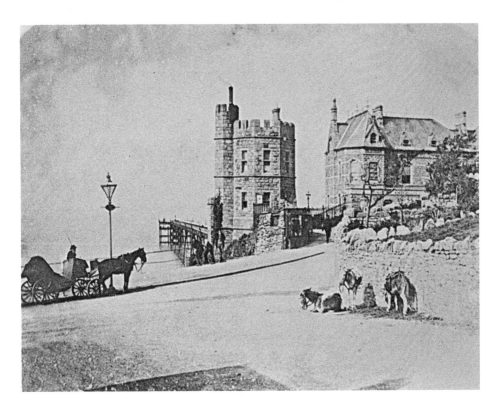

Clevedon Pier, 1889

At the entrance to Clevedon Pier stands the Toll House (in the centre of the Victorian picture) and what was the Royal Pier Hotel (on the right-hand side). The Toll House was designed by local architect Hans Price. At the time, the local newspaper, the *Clevedon Courier and Mercury*, commented rather acerbically that 'Price's design unfortunately resembles a sham castle, or chalk ornament affixed to a cake'. In the forefront of the old picture is a donkey stand – the original donkey rides commenced at the top of the beach.

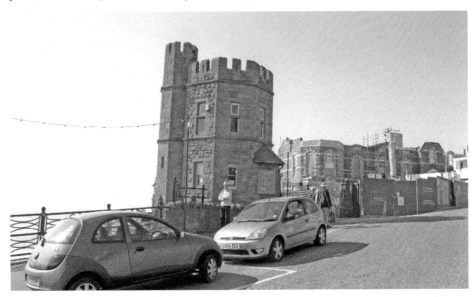

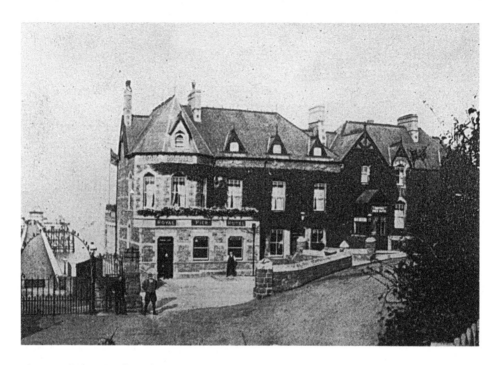

The Royal Pier Hotel, Early 1900s
Built in 1823 by Thomas Hollyman, and originally known as the Rock House, the building was expanded in 1868 by Hans Price in time for the opening of the pier, and renamed the Rock House and Royal Pier Hotel (later shortened to the Royal Pier Hotel). The hotel fell on hard times at the end of the twentieth century and after its closure in 2001, the premises fell into disrepair. Permission was granted for the site to be developed into apartments, with the proviso that the façade remained, and work commenced on the project.

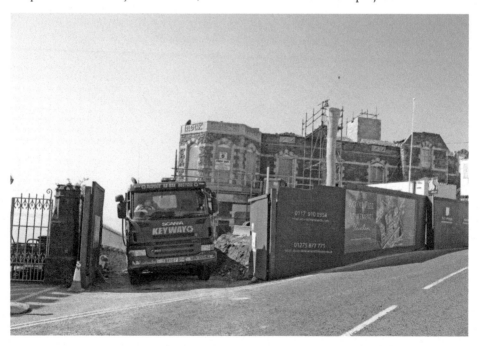

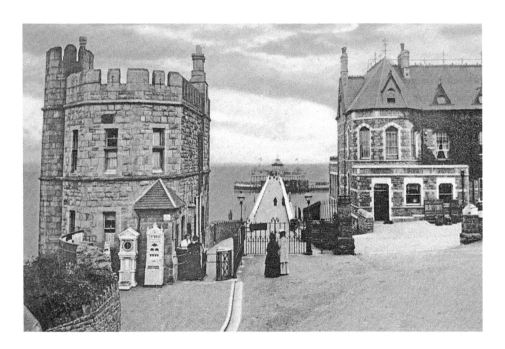

Clevedon Pier, Early 1900s

The Toll House was built by Clevedon builder William Green to architect Hans Price's Scottish Baronial-style design (which included imposing crenelated walls). Besides the toll booth itself, there was room for the accommodation of a pier master. The entrance gates and railings were made locally by Turner & Sons. Today, the Toll House is the home of the Clevedon Pier and Heritage Trust and still operates as the entranceway to the pier and an art gallery. Recently, the pier was raised to a Grade I listing, making it the only structurally intact pier in the country to hold that honour.

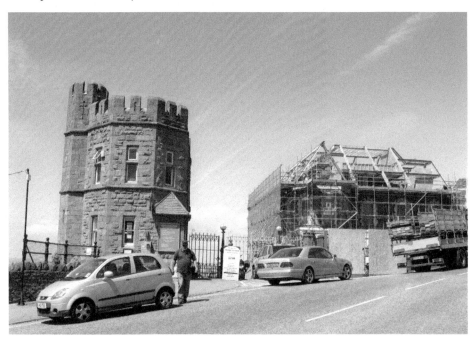

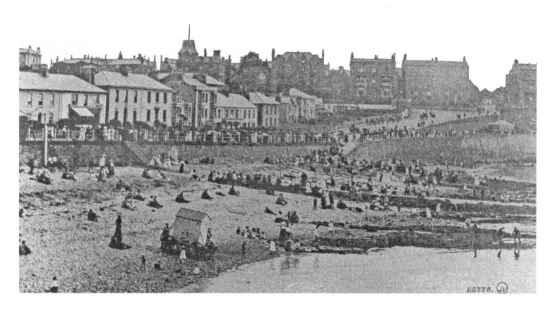

View Over The Beach, Early 1900s

Taken from the pier, this is the view looking south across Clevedon Bay. The houses date back to Clevedon's first period of growth in the Georgian and early Victorian period. Note the bathing hut on wheels in the foreground, and the landing stage behind it stretching across the beach and into the sea. Bathing hut hire was being advertised as far back as the 1820s. At the time, ladies and gentlemen bathed separately (when this picture was taken only ladies were allowed to bathe on The Beach). It was not until the 1930s that mixed bathing in Marine Lake is mentioned.

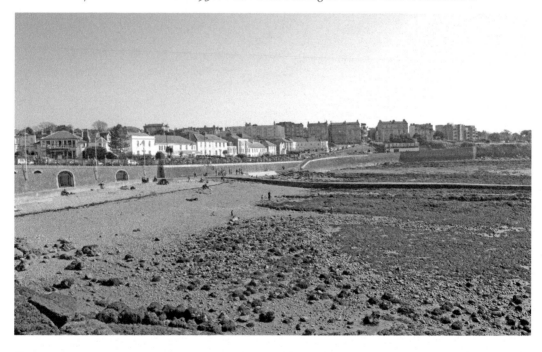

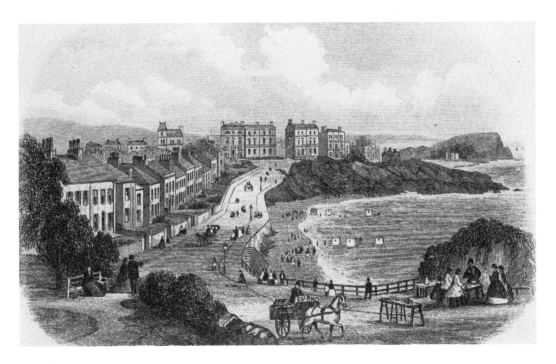

The Beach Engraving, *c*. 1870s

This nineteenth-century engraving is from the end of Marine Parade, just above the point where Alexandra Road (on the left) meets The Beach. A group of ladies are enjoying a picnic in the lee of a rock outcrop on the right, and below them several bathing huts are in operation at the edge of the beach. Gas lamps can be seen along the seafront – one of the introductions to the town made by Sir Arthur Hallam Elton.

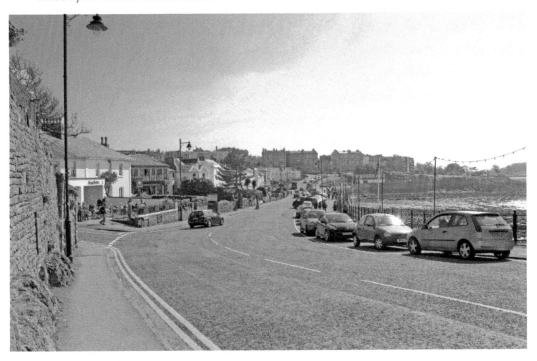

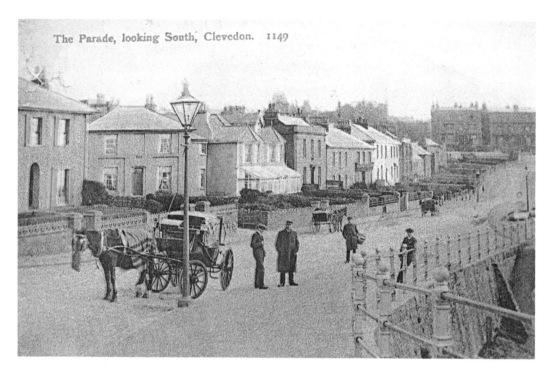

The Esplanade, Early 1900s

Taken before automobiles replaced horse transport, this is a view of the front during a quiet period (the horse drawing the carriage is enjoying a nosebag). Although the two images here are well over 100 years apart, they can easily be identified as being taken from the same spot; the shape of the esplanade had taken its present form by 1875.

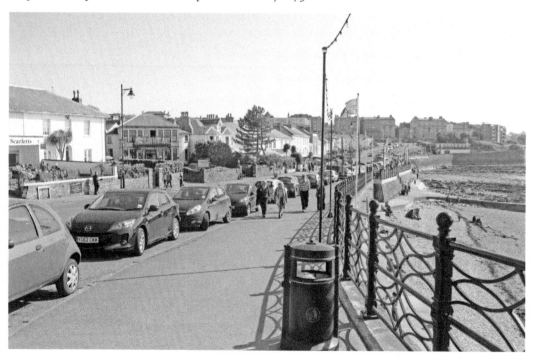

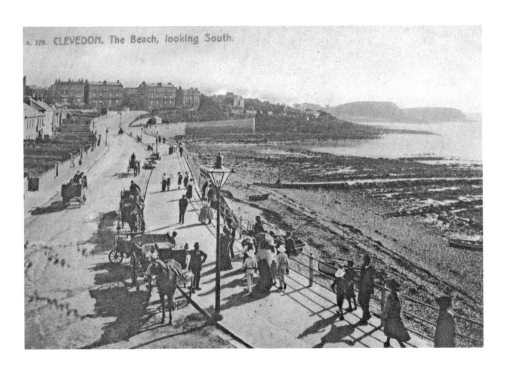

The Beach, Early 1900s

One of the rather unusual features of the seafront houses on The Beach is the presence of their front gardens – we normally associate seaside towns with buildings crowding right up to the shoreline. The older picture here can be dated to the early 1900s, as there is an automobile just behind the horse-drawn carriage in the foreground. Boats have been drawn up the beach – vessels are noticeable by their absence in the modern photograph.

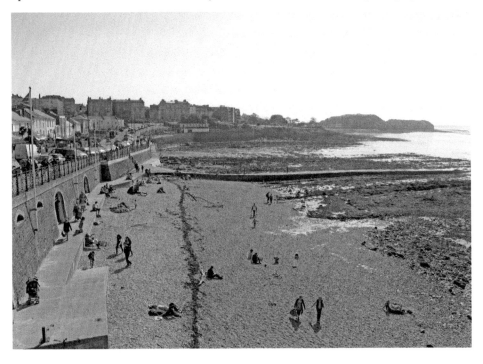

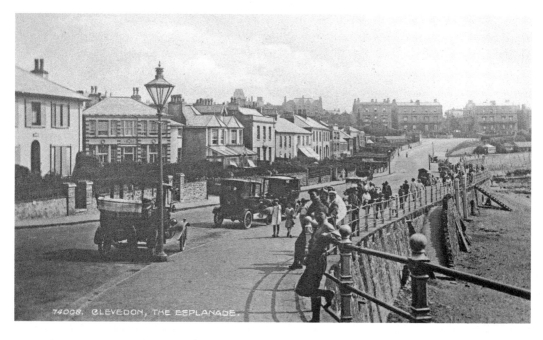

The Esplanade, Early 1900s

In the modern picture, Scarlett's restaurant can be seen on the corner of Alexandra Road. Small cafés, bars and restaurants have lined the esplanade for over a century. In the 1950s, a number of Italian families, such as the Contis, Piscinas and Vellas, arrived in Clevedon and opened up coffee bars and ice cream parlours on the front. In the post-war years, the highlight of the week for the youth of the town was to promenade along the seafront and stop off at one of the coffee bars, such as Aldos. Residents of Clevedon still speak fondly of the establishments, and Mr Vella is remembered in particular as an imposing proprietor in a white apron who would not allow unruly behaviour on his premises.

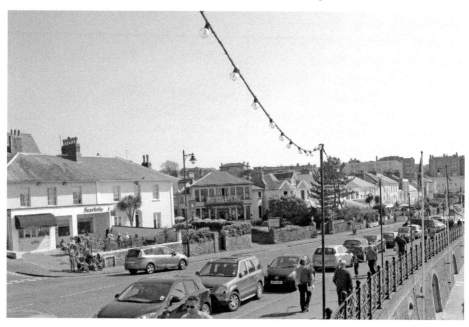

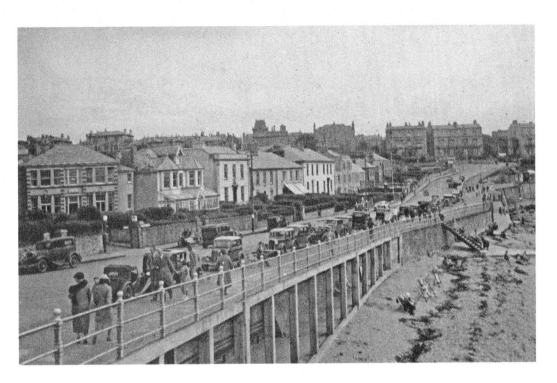

The Esplanade, Early 1900s

The sea wall supporting the esplanade has altered over the years. Rebuilding and reinforcing have been necessary after storm damage. Today, the rather flimsy looking steps leading from the parade down to the beach have been removed, and a walkway has been built on the beach beside the wall (this required the addition of an expanded landing stage for boats).

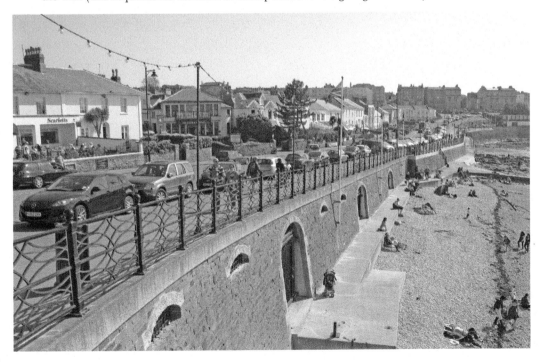

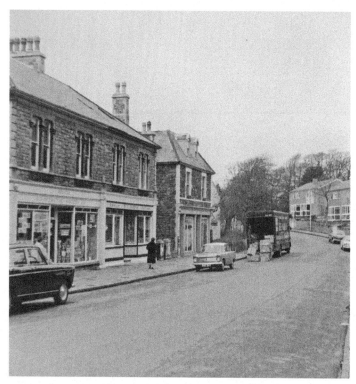

Alexandra Road, 1950s
Seen here looking back towards the seafront, Alexandra Road runs from the meeting point of The Beach and Marine Parade down to the Six Ways junction. The shops on the left, built in 1888, were probably originally intended just as houses (the first 6 feet of the pavement is still owned by the occupiers). The Co-operative Society store was the first mini-market to be opened in Clevedon. The shop next door, Griffin the family butcher, sold up around twenty years ago.

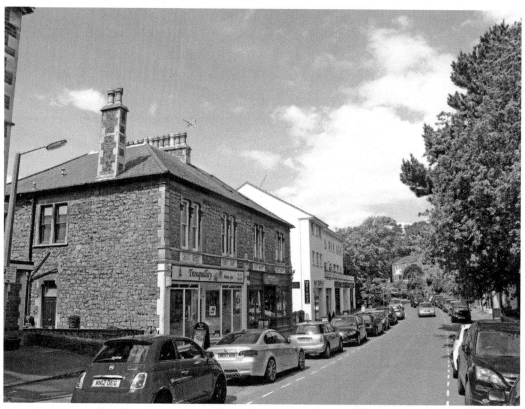

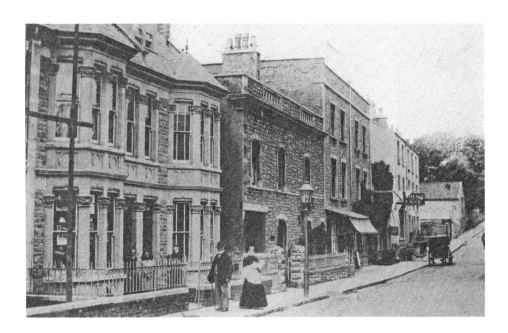

Copse Road, c. 1900

Looking uphill towards Hill Road, we can see the point where Copse Road is bisected by Alexandra Road just beyond the popular Clevedon Community Bookshop (formerly Ernest Shaw's butcher's) and The Royal Oak public house. Copse Road is one of Clevedon's oldest roads. The lower part was first developed in the late 1820s at the same time as properties were going up on The Beach. Further houses were built on this section of the road when some of the adjoining beach gardens were sold. The upper part of Copse Road dates to the 1830s as building continued in the Marine Hill area.

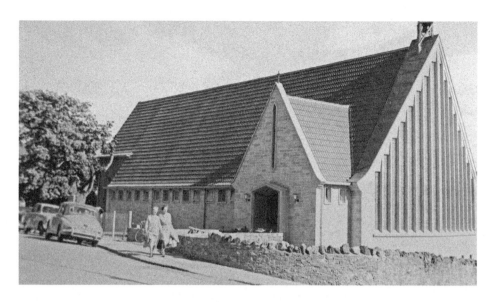

St Peter's, 1960s

Sitting on the corner of Alexandra Road and Copse Road, St Peter's was opened on 9 May 1899 by the Bishop of Bath and Wells to help serve the community on the western side of town. Originally, it had corrugated iron walls and a roof recycled from a redundant school chapel in Margate, Kent. As the congregation grew, the need for a permanent building became clear and Dame Violet Wills (of the famous Bristol Wills family) provided the funds in the 1960s for the construction of the new church next to the old one. In 1984, St Peter's became the home of Clevedon United Reformed church, who came to share the building with the Anglican congregation, and it became a parish in its own right in 1995.

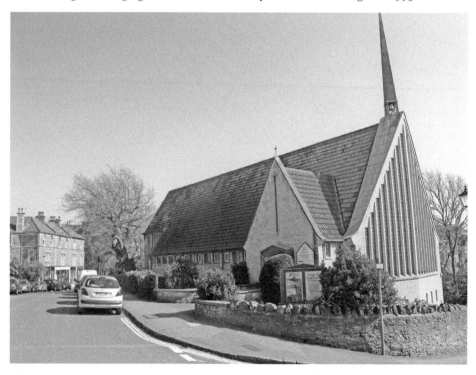

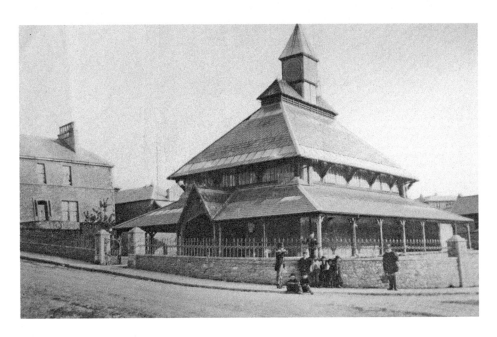

Old Market Hall, Early 1900s

Designed by the Weston-super-Mare architect Hans Price, the Market Hall was opened on 31 March 1869. Modelled on a Scottish distillery, its distinctive pagoda shape ensured clean air was able to circulate over the meat, fruit and vegetables on sale inside. Local tradesmen could sell their produce from one of the twenty-one stalls available to rent three days a week (this was partially a way of curbing the activities of street hawkers). The hall has been put to several uses: in pre-war years it was a brewery; during the Second World War it was occupied by Beatrice Engineering Co.; and then used by a farm implement manufacturers. Today, the Old Market Hall is home to a health club and café.

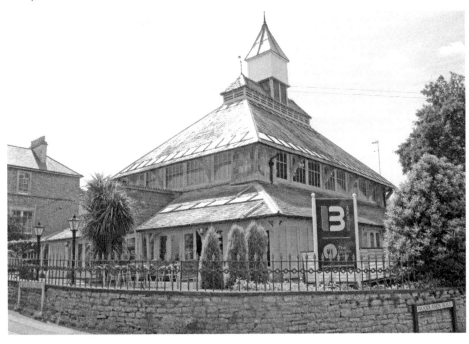

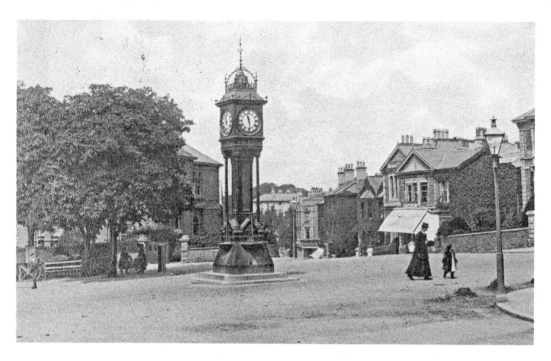

Six Ways, Early 1900s

As its name suggests, the Six Ways stands at the junction of six roads. At the heart of the northern part of Victorian Clevedon, its arterial routes spread out towards Wellington Terrace, the seafront and down to the centre of town. Here we are looking west past its distinctive ornamental clock tower and down Alexandra Road. On the right, Caple's Pacific Stores (the small shop with the impressive awning) is now a family-run sporting goods outlet. To the left is Birklands House, which was left to the town by Victor Cox to be used as a museum.

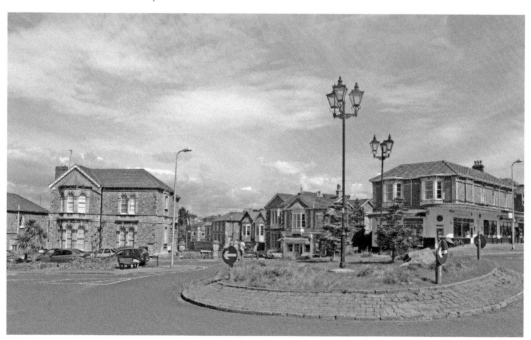

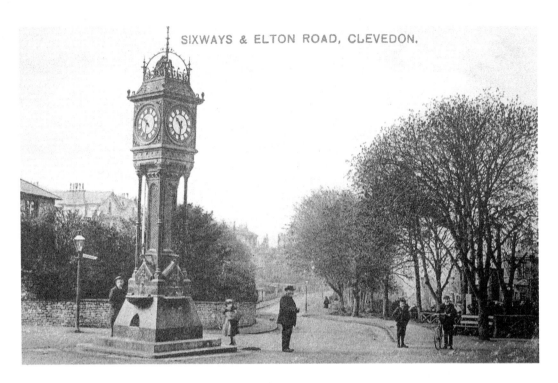

Six Ways, Early 1900s

Unfortunately, Clevedon's second most famous clock tower, which was erected to commemorate the Coronation of Edward VII, is no longer with us (it was scrapped for the Second World War effort). It has been replaced with a pair of ornate street lights atop a roundabout. Sadly, as we look down Elton Road here towards the seafront, we can see that the street lamps revert to the standard mundane design.

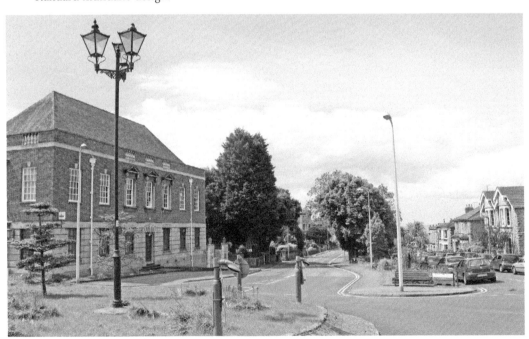

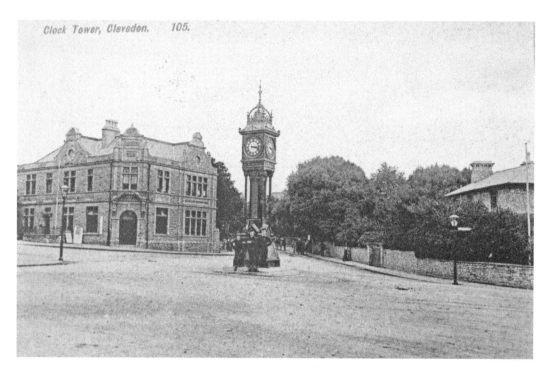

Clock Tower, Clevedon. 105.

Six Ways, Early 1900s
On the right-hand side of the picture can be seen the General Post Office building, while across the road is the striking Mercury building, designed by Hans Price, which housed the Clevedon Printing Company offices. Linden Road leads off to the left of the Mercury building (which is now a branch of Barclays Bank).

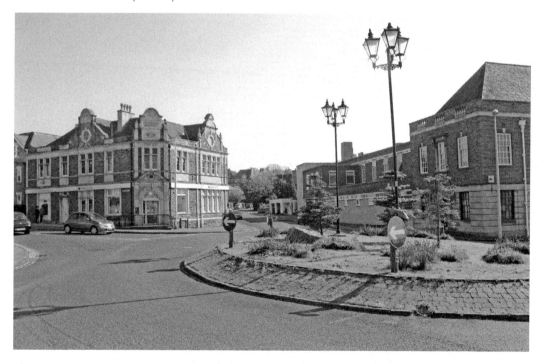

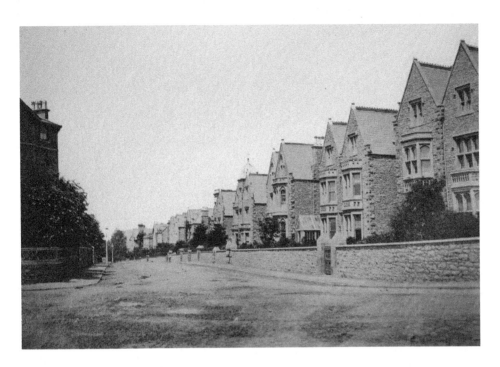

Linden Road, Early 1900s

Viewed here at the corner of Prince's Road looking back towards Six Ways, Linden Road has an imposing row of semi-detached Victorian villas. The buildings on the right have now been converted into a retirement home, while further down the road is the tranquil haven of Herbert Garden.

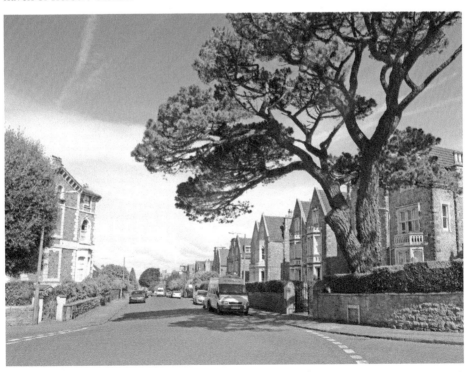

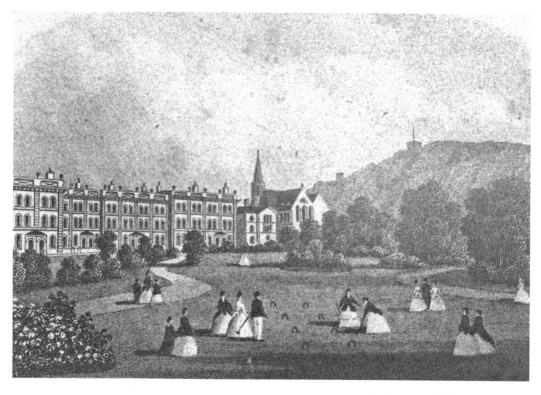

Herbert Garden, 1871

This etching of September 1871 looks north-west across Herbert Garden towards Hill Road. The ladies and gentlemen are engaged in a game of croquet. This 3-acre 'green lung' in the town is still used for sporting purposes; tennis courts are laid out in the grounds. It is also used as the starting point of carnivals and other community activities.

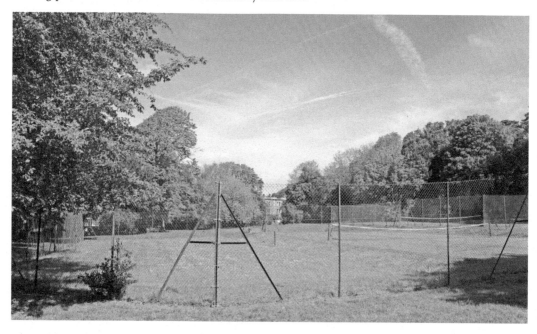

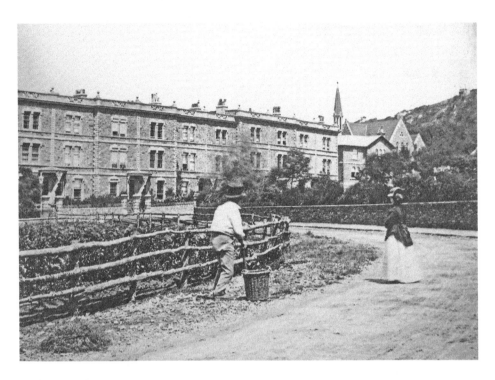

Herbert Garden, *c.* 1890s

Herbert Gardens were another gift to Clevedon from the Elton family (Sir Arthur Hallam Elton donated the land in 1865). Here we are looking across the western end to Herbert Road. The spire of the Congregational church in Hill Road can be seen peering over the roofs.

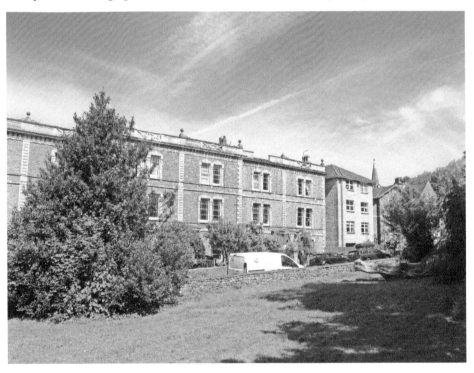

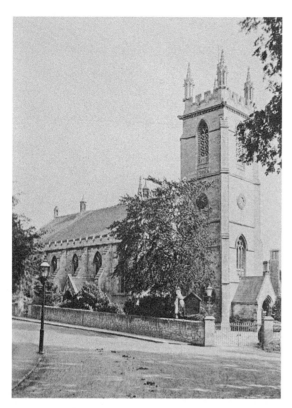

Christ Church, Early 1900s

Standing on the corner of Highdale Road and Chapel Hill, Christ Church was designed by Thomas Rickman in a 'low church' style and built in 1839. It was constructed as a result of the growing population of Clevedon's need for a more conveniently located church (St Andrew's was felt to be rather isolated). The Revd Sir Abraham Elton donated half an acre of land and George Weare Braikenridge provided a £1,000 endowment and a further £500 towards the cost. The tower, which dominates the landscape from the lower part of town, was designed in a medieval style.

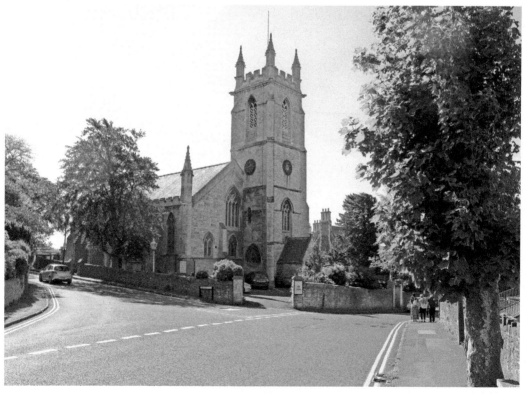

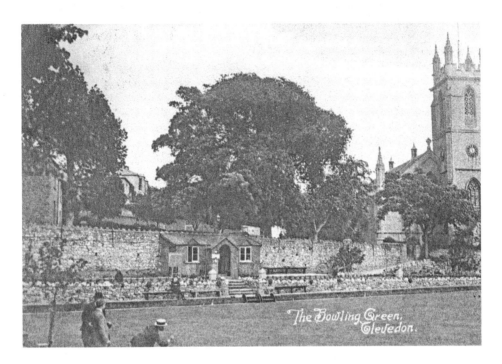

Christ Church, c. 1920s

Across the road from Christ Church is the Clevedon Bowling Club. It is a mixed club, whose members can enjoy the use of both indoor and outdoor greens. The club was formed in 1910 with Sir Edmund H. Elton as president. It was originally located by the tennis courts in Linden Road, but in 1911 the club moved to its present home on Chapel Hill. In 2000, female members were first admitted.

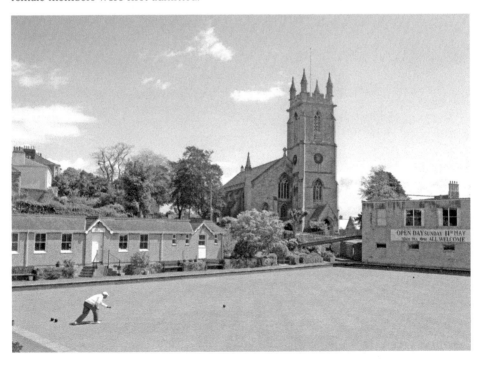

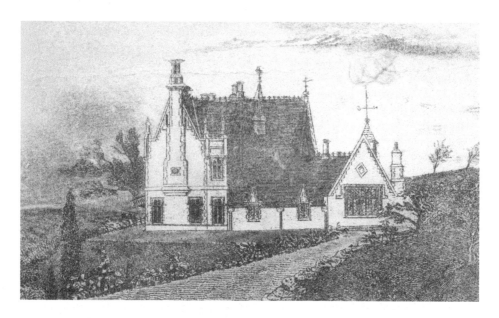

Mount Elton, Highdale Road, Mid-1800s

Built in 1844 for the Dowager Lady Mary Elton, widow of Sir Abraham Elton, Mount Elton was designed by the architect Samuel Whitfield Daukes in the Eclectic style. Later it was home to the Revd Stephen Saxby, vicar of All Saints church, and then Commander Henry Shore, whose most notable legacy to the landscape of Clevedon is the bridge spanning Highdale Road. This was designed to connect Mount Elton with part of its grounds across the road, but was to prove to be a bone of contention with local councillors, who were concerned it would be an eyesore and might 'frighten the horses'. Permission was finally given and the bridge built in 1898. Today, it still stands over the road but is in a state of disrepair.

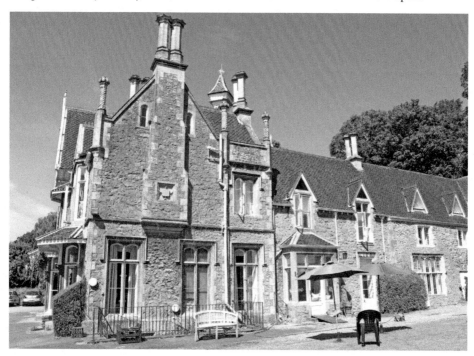

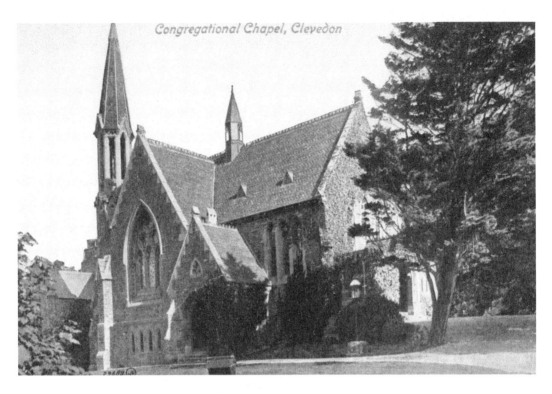

Congregational Chapel, Clevedon

Congregational Church, Hill Road, Early 1900s
The Congregational church on Hill Road was opened for public worship on 4 June 1856. It was designed by Foster & Wood in the early English Decorated style, and has a distinctive, thin spire. The chapel has now been converted into flats.

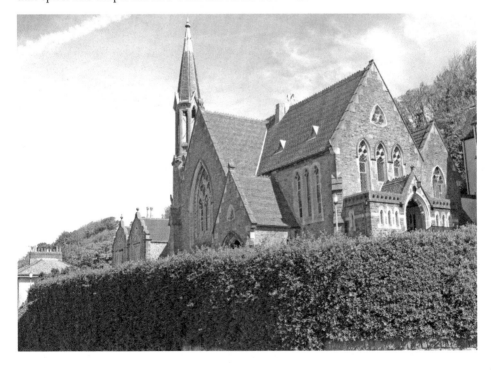

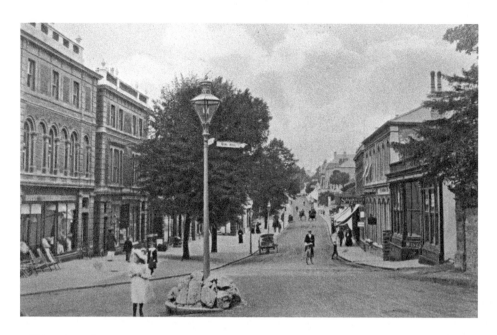

Hill Road, Early 1900s

Built on the slopes of north Clevedon, Hill Road runs up from Chapel Hill to Marine Hill. This part of Clevedon was not suitable for agriculture, but did provide wonderful building potential due to its splendid vistas across the lower town, open fields in the south and the sea. By the 1840s, Hill Road, along with Highdale Road, Wellington Terrace, Copse Road and The Beach, was part of 'New Clevedon'. The Georgian and Victorian properties were popular with wealthier residents and provided accommodation for visitors eager to enjoy the charms of the beachfront and the refreshing sea air.

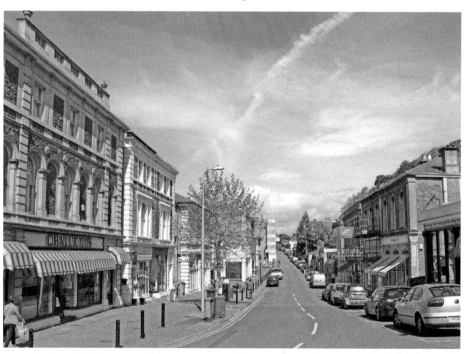

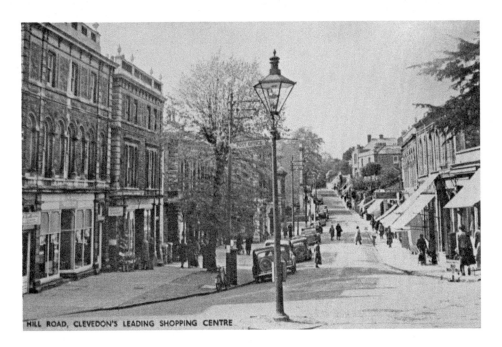

HILL ROAD, CLEVEDON'S LEADING SHOPPING CENTRE

Hill Road, Mid-Twentieth Century

Hanging on the lamp post in the centre of the picture is a signpost to the General Post Office at Six Ways. The 'four floors of showrooms' on the left of the modern picture, which was put up for sale in 2014, belonged to the furniture retailers Challicoms. Challicoms first opened as Clevedon Depository and House Furnishers in 1858 by Mr C. E. Challicom. It moved into its final premises in 1872, and offered a variety of services including removals, warehousing furniture and hiring mail carts and wheelchairs. The Dark family bought the business in 1949 and ran it until their retirement.

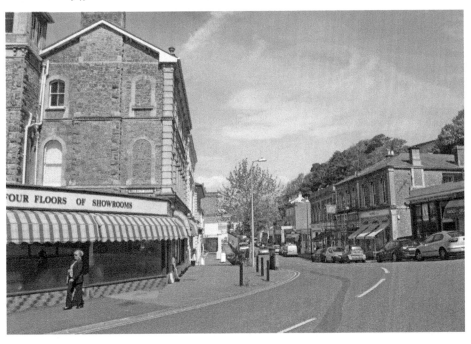

FOUR FLOORS OF SHOWROOMS

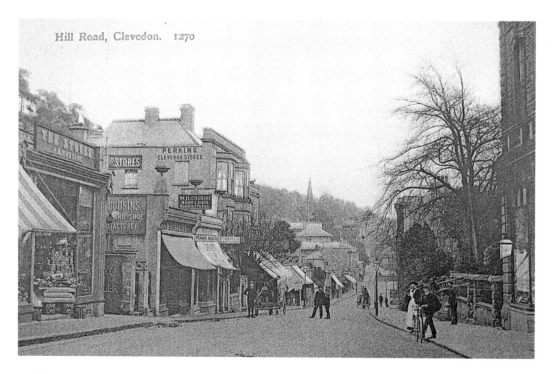

Hill Road, Early 1900s

In the nineteenth century, the shops on Hill Road were of a higher class than those in the lower part of town known as the 'Old Village', with an emphasis more on tea rooms, delicatessens, haberdashers, clothing and shoe shops. Seen here, between W. H. Cousins Boot and Shoe Manufacturer and Perkins Clevedon Stores, is Franks, an establishment offering 'Accommodation for Cyclists'.

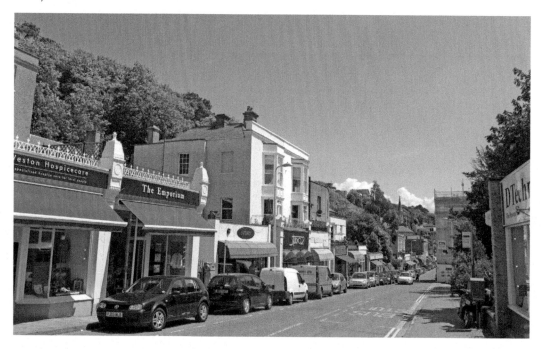

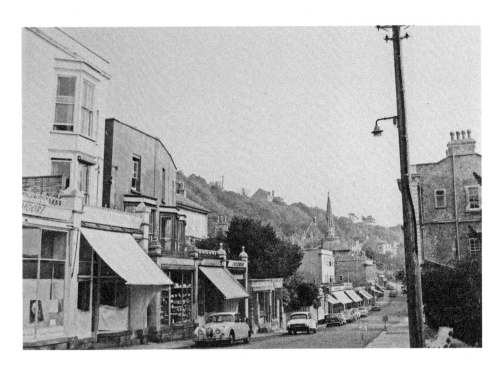

Hill Road, 1960s

A wide variety of shops could be found beneath the awnings on Hill Road in the mid-twentieth century. Here, looking east towards Chapel Hill and Highdale Road, are an ironmongers, a laundrette, a tobacconist, a patisserie, a radio shop and several cafés. There was one large grocery store called International Stores. On the right was a branch of the NatWest bank (before that Stukelys bank) in an imposing Georgian building.

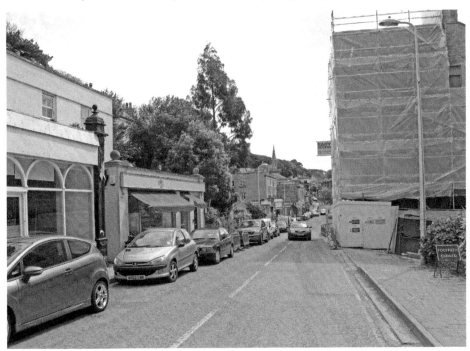

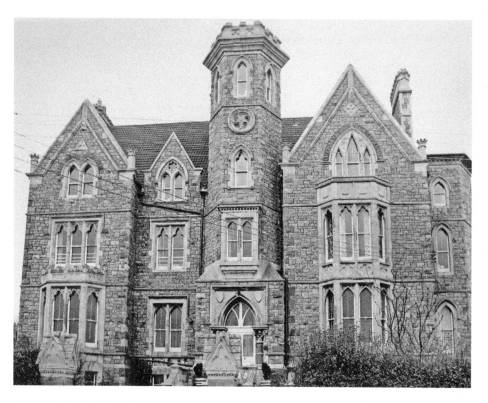

St Ediths, Dial Hill, Early 1900s

Built in 1870 by Revd Jabez Horne and originally called Hallam Hall, the building operated as a boarding school for about ten years before it was taken over by the Community of the Sisters of the Church, who renamed it St Edith's. For nearly 100 years it was run as a children's home, catering for up to sixty orphans until it was forced to close in January 1975. Today the Grade II* building continues to dominate the skyline over Clevedon, and although it is still known as St Edith's, it has now been turned into apartments.

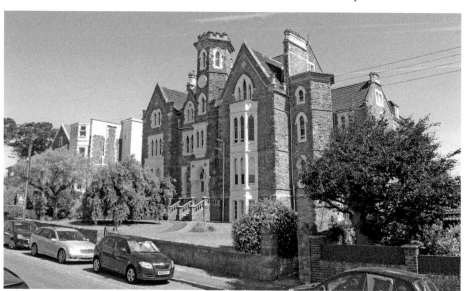

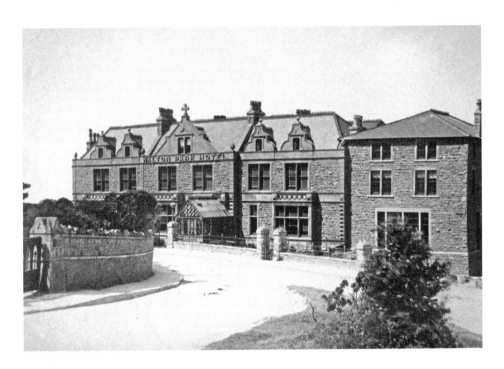

Walton Park Hotel, Wellington Terrace, Early 1900s

Sat at the northern end of Wellington Terrace, with a commanding view over the Bristol Channel and the Welsh hills, the Walton Park Hotel is a grand Victorian property set in over 2 acres of garden. Built by the Walton Park Hotel Company through a subscription system at the end of the nineteenth century as a response to a shortage of hotel accommodation (several establishments in Hill Road had closed), the hotel is now fully restored and run by Best Western.

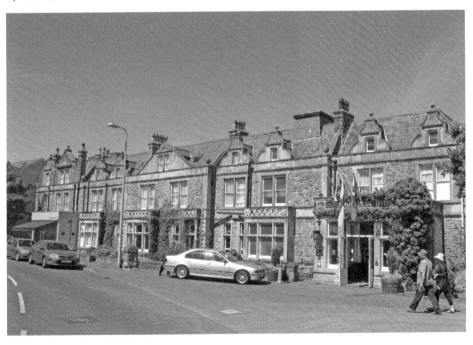

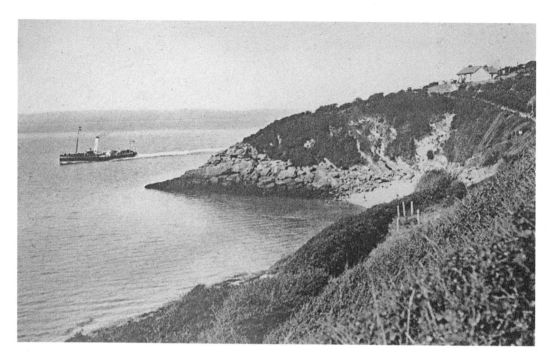

Ladye Bay, Early 1900s

Just north of Wellington Terrace lies Ladye Bay. A paddle steamer can be seen here rounding the corner of Ladye Point heading towards Clevedon Pier. Access to the beach is via a small path at the northern end of the bay. Because of its location and access problems, it has not been developed in the same way as the rest of Clevedon's seafront.

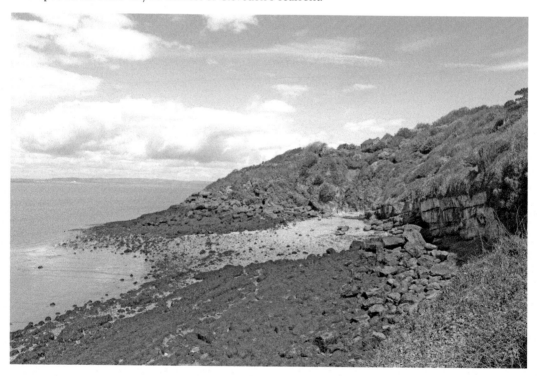

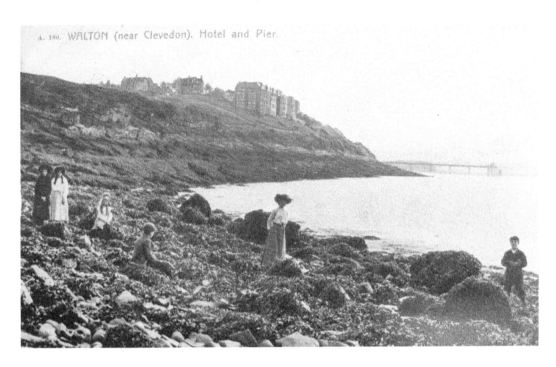

A. 180. WALTON (near Clevedon). Hotel and Pier.

Ladye Bay, Early 1900s

The beach in Ladye Bay was popular with visitors who wished to escape from the crowds along The Beach and The Promenade. As can be seen here, it is still enjoyed by those who prefer the quiet life. The bay is the start-off point for Clevedon's annual Long Swim, a mile-long swim to the pier. This competition dates back to 1928, when men and women jumped over the side of boat and set off for the finishing line beneath the pier.

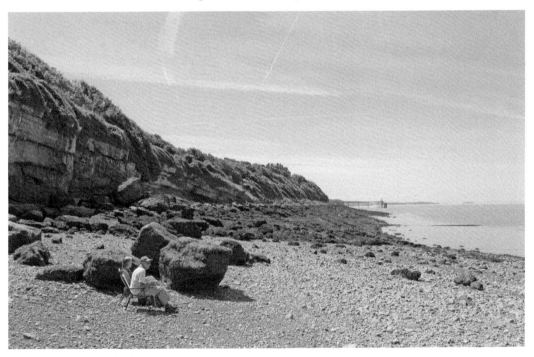

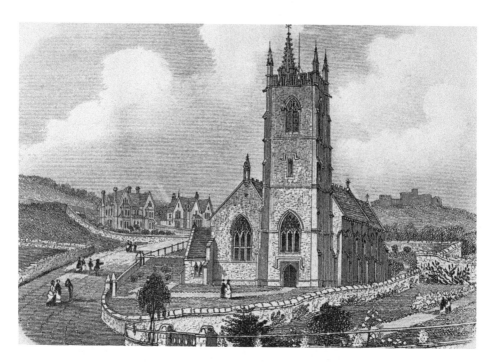

Walton St Mary Church, Castle Road, 1850s

Walton St Mary lies to the north of Clevedon and merges into its suburbs. It is now known primarily for Walton Castle, which was a ruin for many years before being privately bought and renovated, and Walton St Mary church. The original church was built sometime in the twelfth century in a small village then called Stoke-super-Mare. Records show that it was dedicated to St Paul, but for reasons unknown the village disappeared and the church became derelict.

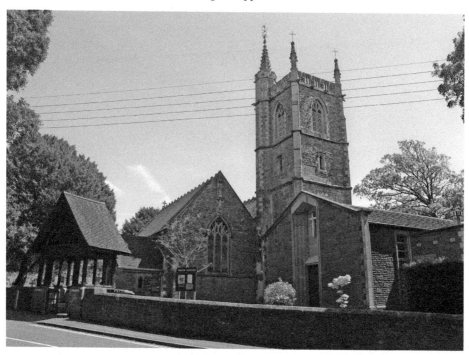

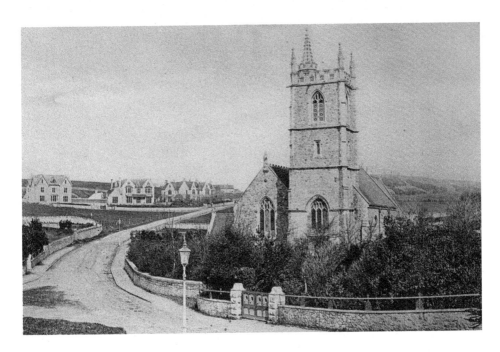

Walton St Mary Church, *c.* 1890s

With the development of Walton Park in the second part of the nineteenth century, it became clear that a church was required to minister to the residents' religious needs. Consequently, in 1869, rebuilding began on the site of the original church, and the next year the Bishop of Bath and Wells consecrated the newly named Walton St Mary church. Looking north-east in the old picture, we see the church sat in a relatively sparsely housed neighbourhood. In the modern photograph, which faces south-west, we see the back of the church. Little remains of the original structure save some stonework at the foot of the tower.

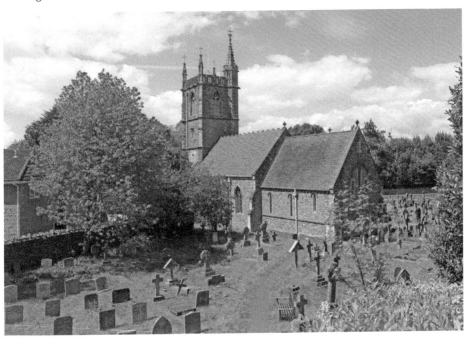

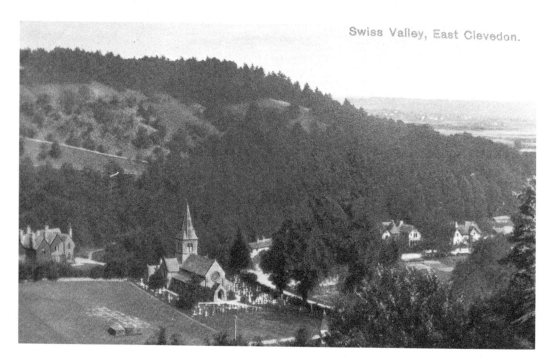

Swiss Valley From Strawberry Hill, Early 1900s

This elevated view is of Swiss Valley in East Clevedon. Originally, it was populated by poor labourers who had to trudge over 2 miles to St Andrew's, the parish church. Consequently, Sir Arthur Hallam Elton and Lady Elton felt it incumbent on them to provide a convenient place of worship for the locals. Lady Elton laid the foundation stone on 25 May 1859 and it was consecrated on 1 November 1860 by the Bishop of Bath and Wells.

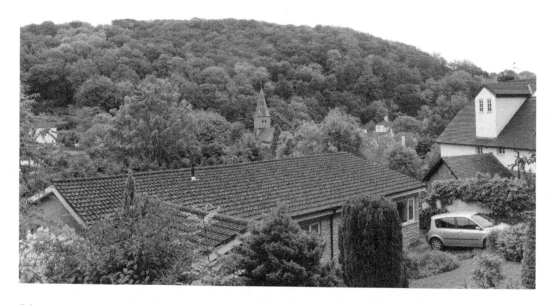

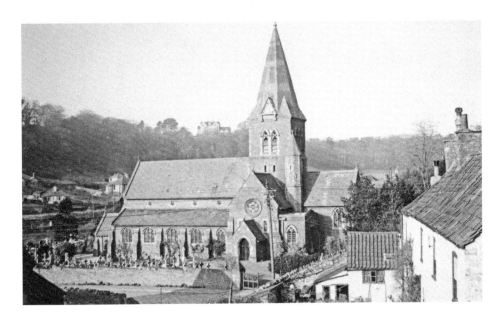

All Saints Church, *c.* 1930s

This view of All Saints church is taken looking north from the top of All Saints Lane (which was originally called Carey's Lane). The architect C. E. Giles designed the church in the Gothic style, the popularity of which among Victorian and Edwardian visitors can be judged by the number of postcards produced of the church in the Swiss Valley. Although the first vicar, the Revd Stephen Saxby, who lived in nearby Mount Elton following his marriage to its owner Jane Euphemia Brown, was a much respected scholar (he was a fellow of the Royal Society), he appears to have been a man with intransigent views; when the Burial Act of 1881 allowed Nonconformist ministers to conduct funerals in the churchyard, he locked the church doors in protest.

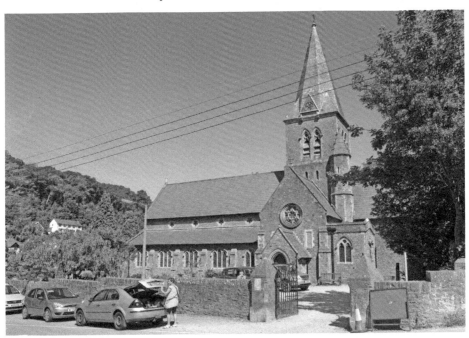

Acknowledgements

The author would like to express his gratitude to the staff at Clevedon Library, the Frederick Wood Room in Weston-super-Mare Library, the Bristol Record Office, the Bristol Reference Library, the Clevedon Civic Society, Andy Brisley, RoseMary Musgrave and, especially, John and June Hudson, and to the many local authors and historians who have contributed to the knowledge and appreciation of the history of Clevedon through the years. The following books were of great assistance: *Clevedon Past* and *Clevedon, From the Village to the Town* (both published by Clevedon Civic Society), *Clevedon in Old Photographs*, collected by Jane S. Lilly, and *Clevedon Town Guide* (Clevedon Town Council).

The following are the reference numbers for the images reproduced from the Clevedon Library archives: 7/5, 7/7, 7/8, 7/9, 7/13, 7/14, 7/19, 7/25, 7/26, 7/29, 7/38, 7/40, 7/58, 28/5, 28/44, 28/45, 28/46, 28/47, 28/49, 28/51, 28/55, 28/57, 28/58, 28/62, 28/63, 28/66, 28/68, 39/33, 39/34, 39/36, 39/38, 48/30, 48/35, 48/41, 50/6, 68/10, 68/11, 68/12, 68/13, 68/14, 68/17 and 68/18.

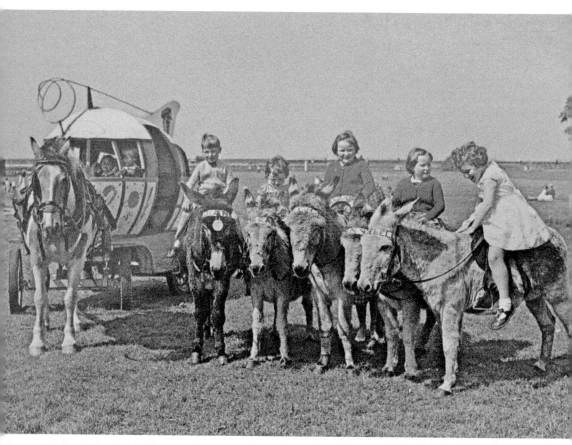

Donkey rides on Salthouse Fields in the 1960s.